HARRY LIEBERMAN

A JOURNEY OF REMEMBRANCE

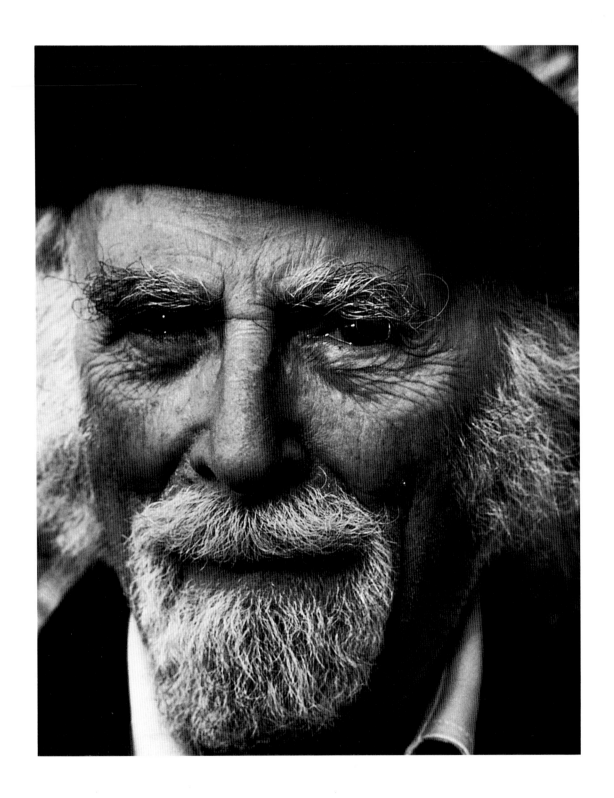

1. Portrait of Harry Lieberman by Harlowe Stengel, Los Angeles, California, c.1976. (Collection of the artist's family)

HARRY LIEBERMAN

A JOURNEY OF REMEMBRANCE

STACY C. HOLLANDER

Dutton Studio Books New York
In association with the
Museum of American Folk Art New York

DUTTON STUDIO BOOKS

Published by the Penguin Group
Penguin Books USA Inc., 375 Hudson Street,
New York, New York 10014, U.S.A.

Penguin Books Ltd, 27 Wrights Lane,
London W8 5TZ, England

Penguin Books Australia Ltd, Ringwood,
Victoria, Australia

Penguin Books Canada Ltd, 2801 John Street,
Markham, Ontario, Canada L3R 1B4

Penguin Books (N.Z.) Ltd, 182–190 Wairau Road,
Auckland 10, New Zealand

Penguin Books Ltd, Registered Offices:
Harmondsworth, Middlesex, England

First published by Dutton Studio Books, an imprint of Penguin Books USA Inc.

First printing, June, 1991
10 9 8 7 6 5 4 3 2 1

Library of Congress
Catalog Card Number: 91-71215

Printed and bound by Dai Nippon Printing Co., Ltd., Tokyo, Japan
Book designed by Marilyn Rey

ISBN: 0-525-93308-5 (cloth); ISBN: 0-525-48593-7 (DP)

CONTENTS

ACKNOWLEDGMENTS

I have never lived in an East European shtetl, nor was I raised as a Hasidic Jew, yet my first response to Harry Lieberman's paintings was one of immediate recognition. As I became more familiar with the artwork and with Harry Lieberman's life, I found certain parallels to my own experiences that have made me feel close to the artist and to the themes that he painted.

Studying Lieberman's paintings has been something of a road to self-discovery. I have learned more about Judaism than I knew and understand better the reasons why I was born in America, rather than in Poland, Lithuania, or Latvia. Although this is not what I had anticipated when I started this project, the book and related exhibition have held deeper meaning for both myself and my family because of it.

I was raised on the Lower East Side of Manhattan, near the streets that offered Lieberman a new start in America. My mother has lived her whole life on the Lower East Side and her East European parents moved to East Broadway, in the neighborhood, during the 1920s. While my grandfather Benjamin Fleischer, an Orthodox rabbi, led his congregation Beth HaMidrash HaGadol on Norfolk Street, Harry Lieberman was operating his wholesale candy store on Ludlow Street, just a few blocks away. There were many such candy and dried-fruit stores then, and although my mother cannot recall Lieberman's particular shop, she and I can imagine how it must have looked from the shops that still thrive in our neighborhood—stores that look the same way they have for decades.

As I have met and spoken with Lieberman's family, we have discovered that we share neighborhood memories and are familiar with many of the same landmarks. I appreciate the relationship I have developed with Lieberman's daughters and his granddaughters, and it is my hope that this exhibition

of paintings by Harry Lieberman will invite a wider audience to glimpse this corner of the world.

I would like to thank the Popkin family for their unflagging support and generosity of time and information. This publication and exhibition would not have been possible without the unqualified flow of facts and stories supplied by each of them. I would also like to thank Steven Siegel for taking the time to give me a "crash course" in Jewish genealogy. I would never have known that so much material from Eastern Europe had survived, nor could I have found my way through the maze of municipal records without his guidance. Rabbi Haskell Bernat's help in translating and finding sources for many of the stories which form the subjects of the paintings has been invaluable. I would also like to thank Rivka Fingerhut for her comments. Jack Goldstein has shared his wonderful and painful memories of Gniewoszów. John Parnell's photographs allow the brilliance of Lieberman's colors to shine from these pages and my gratitude goes to Gavin Ashworth for additional photography in figures 6, 38, 44, 59, 72, and 74. The staff of the YIVO Institute, and Marek Web in particular, were kind and helpful and did not make me feel foolish for not speaking Yiddish. Esther Brumberg of the Museum of Jewish Heritage in New York helped me with historical information about Gniewoszów. The Hebrew Union College Skirball Museum in Los Angeles willingly shared materials that have been vital for the preparation of this publication. Father Papeians helped me understand how special Lieberman's short stay at Saint Andrew's Priory had been. Joan Ankrum was my link to the West Coast. I was delighted to meet Jeanne Barron whose encouragement launched Harry Lieberman on his career as an artist. I have enjoyed many elucidating conversations with Gerard Wertkin,

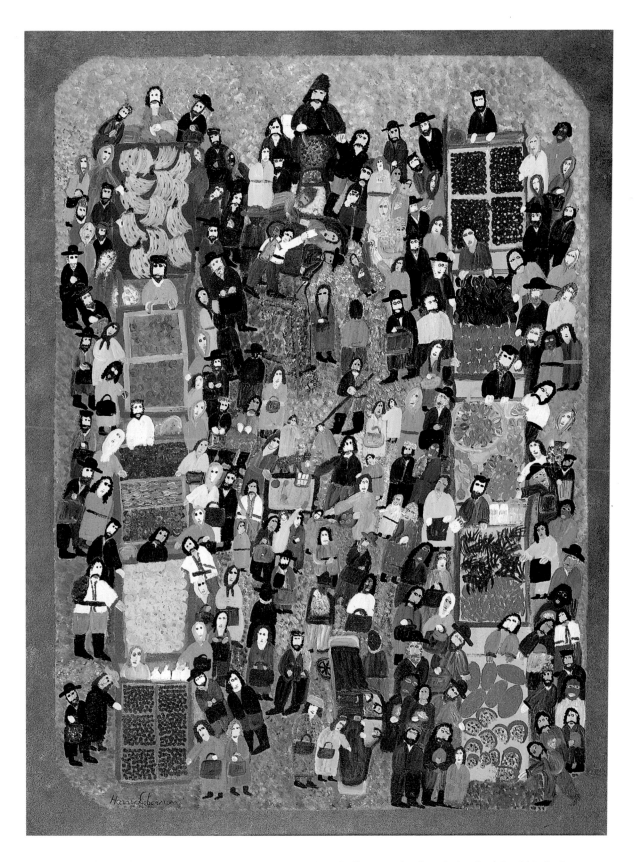

2. *East Side Market*, c.1970, acrylic on canvas, 40″ x 30″. (Collection of Arlene R. Popkin) In 1906, the Lower East Side of New York City was one of the most densely populated areas of the world. Lieberman's painting reflects the ethnic diversity of the neighborhood and the dizzying array of goods peddled through its streets. Pedestrians, peddlers, shoppers, and vehicles throng the streets creating a melange of sight and sound. Familiar turn-of-the-century sights include the organ grinder with his monkey and the horse-drawn wagon, while an automobile congests the streets near the bottom of the canvas.

Assistant Director, Museum of American Folk Art, New York City, and I am indebted to Edith Wise, Librarian, Museum of American Folk Art, for her always generous help. My thanks go to Tim Perrin for his translation of the Polish records and for the excitement of hearing aloud words written a century ago in Poland. I would like to thank all the lenders, both those who wish to be named—David L. Davies, Lanford Wilson, Celia Hubbard, Mr. and Mrs. Lawrence Schoenbach, Dr. and Mrs. Stephen Hirschberg, Elinor Blake, David Blake, Helen Popkin, Morris Weisenthal—and those who wish to remain anonymous. The cooperation of Phyllis Rosenzweig, Judith Zilczer, and the staff at the Hirshhorn Museum and Sculpture Garden in Washington, D.C., and of Judy Chiba-Smith of the Museum of International Folk Art in Santa Fe, New Mexico, has been greatly appreciated. Cyril I. Nelson, editor of Dutton Studio Books, was helpful in the preparation of this book. To my husband, Stephen, and my daughter, Sophia, thanks for your love and support. And, last, a very special thanks to Elizabeth Warren for her continual encouragement and belief that I could do the job.

INTRODUCTION

Harry Lieberman's paintings have excited attention in the folk-art world almost from the moment he first picked up a paintbrush. Lieberman was included among the vanguard of contemporary folk artists presented in Herbert Hemphill and Julia Weissman's seminal work, *Twentieth-Century American Folk Art and Artists* (1974) and his paintings have since appeared in such important publications as *Five Star Folk Art: 100 American Masterpieces*,[1] *Pioneers in Paradise: Folk and Outsider Artists of the West Coast*,[2] *Reader's Digest*,[3] and *The New York Times*.[4] In 1981, the Hebrew Union College Skirball Museum of Jewish Art in Los Angeles presented an exhibition of more than eighty paintings by Harry Lieberman and there have been numerous gallery showings of his work on the West Coast and in Florida, as well as in New York.

Lieberman's paintings are represented in such prestigious museum collections as the Boymans-Van Beuningen Museum in Rotterdam, and the Hirshhorn Museum and Sculpture Garden in Washington, D.C. They are also found in the private homes of Hollywood stars, folk-art collectors, and leaders in the Jewish community. Yet, despite the wide exposure and acclaim they have consistently received, Lieberman's paintings are frequently viewed in the folk-art community merely as charming and colorful renditions of religious themes and East European-shtetl life, without further discussion or interpretation. However, an examination of the political and social climate that prompted Lieberman's emigration to America and the religious environment that formed his basic philosophy, encourages the viewer to return to the canvases with a deeper appreciation.

When Lieberman emigrated to America, he could not know that the way of life he left behind would not survive much longer. In the wake of historical events, his paintings assume greater significance as visual records of the folklore, religious traditions, and rhythms of daily existence of the East European communities that were destroyed during World War II. Behind the deceptively simple images Lieberman painted lies a lifetime of experience that spanned two continents and two centuries. This depth of experience endows Lieberman's paintings with the authenticity that makes them so compelling to even the most casual observer.

In his paintings, Lieberman explored themes of acceptance, religious tolerance, and ethical behavior illustrated through biblical stories, Talmudic teachings, and contemporary events. These tales from Jewish folklore, religion, and literature expressed Lieberman's own views and raised moral questions that have gained renewed importance since the Holocaust.

As first-hand memories of the Holocaust recede further and further into history and the generation most intimately affected by its horrors grows older, it becomes imperative to remember what once happened and must never happen again. One of the wonders of Harry Lieberman's paintings is that the painful evocation of this lost community and way of life can be recalled with such loving joy and celebration, allowing all audiences to share in the act of remembering.

JEWISH ART

The definition of American folk art has generated heated discussion since the first exhibition that was presented at the Whitney Studio Club in 1924. A definition of Jewish art has not been more forthcoming. The issue of "Jewish" art has been argued for more

than a century without a consensus. Is Jewish art determined by the specific application of the work, as in religious objects, is it defined thematically and iconographically, or is it merely defined as work by an artist of Jewish heritage? These are some of the questions that art historians have grappled with in their discussions of Jewish art, and they are the same questions that have since been applied to a separate consideration of Jewish folk art in America. In their exhibition catalogue, *The Jewish Heritage in American Folk Art*, authors Gerard Wertkin and Norman Kleeblatt write, "An encyclopedic approach seemed appropriate for the first exhibition devoted to this subject."[5] Wertkin and Kleeblatt note that a true Jewish folk heritage did not appear in North America until the mid-nineteenth century, and arrived with the mass immigration of East European Jews. They discuss the historical "ambivalence" of Judaism to the representational arts that is contained in the Second Commandment:

> Do not have any other gods before Me. Do not represent [such gods] by any carved statue or picture of anything in the heaven above, on the earth below or in the water below the land. (Ex.20:3–4)

However, they suggest that this ambivalence has acted as a "challenge," rather than a proscription.

Jewish participation in the visual arts is documented as early as 245 CE in the paintings and mosaics of the Syrian Dura-Europos synagogue, and most prominently in illuminated Hebrew texts, but there is no long-standing tradition of Jewish art to which Lieberman's paintings specifically belong. Avram Kampf writes, "In the West the notion of Jewish art arose largely from the needs of the Jewish minority to affirm a distinct cultural identity…"[6] The conception of a "Jewish art" in Russia had already been established in the nineteenth century, partially formulated by Vladimir Stassof, a Russian art critic who strongly championed both national and ethnocentric art. In 1878, Stassof wrote, "…What the artist is born with, the impressions and images that surround him, among which he grew to manhood, to which his eye and soul were riveted, only that can be rendered with deep expression, with truth, and genuine force."[7] This statement generally supported the work of artists whose sentimental realism bore out the premise of Stassof's theory. But the Russian-Jewish artists emerging between the Russian Revolutions of 1905 and 1917 were moving away from nineteenth-century realism and struggling to reconcile their own cultural experiences with the growing abstraction of the international art world. In the search for artistic roots to integrate into this international style,

the artists turned toward the folk art of both their national and religious heritage as it was found in "lubok," or folk prints, Russian icons, and synagogue art.[8] Many of these same "folk" sources may have formed the visual environment of Lieberman's youth in a Russian-Polish shtetl.

ETHNIC AND RELIGIOUS FOLK ART

Ethnicity has been a recurring aspect of American folk art, as seen in the enduring interest in art produced by the Pennsylvania Germans and other self-contained ethnic groups. The folk and decorative arts of these communities are often reflective of the forces that have molded their cultural identities. The work of Jewish artists as an ethnic group presents some difficulty in light of the attempts by the vast majority of Jewish immigrants to assimilate to a mainstream American ethic. Unlike separatist groups, who have tried to maintain their traditions in as pure a form as possible, a large percentage of Jewish immigrants have freely adapted many of the customs they found in America while continuing to practice distinctly Jewish traditions. The work of artists like Lieberman, who discarded the overt rituals that separated him from non-Jewish Americans, was not produced in isolated circumstances without exposure to cultural diversity, but created in spite of it.

The question of the religious impulse in American folk art has also been one that continually intrigues researchers and scholars in this field. Harry Lieberman's paintings are generally considered both ethnic and religious because they deal primarily with Jewish liturgy, religious literature, and Jewish shtetl-life in Poland. But if we accept the term "religious art" to denote works that are created with the purpose of disseminating a religious message, Lieberman's paintings assume a somewhat different definition. The Reverend Howard Finster and Sister Gertrude Morgan are contemporary folk artists whose artwork is consciously proselytizing, and both these artists began painting as a means of spreading their religious message to a wider audience. Lieberman's paintings, on the other hand, were not intended to convert the viewing public. They were visual statements based on his own memories, his own background, and his own education. That this education was mainly limited to the study of works that constitute the foundation of Judaism—the Torah and the Talmud—does not belie the fact that philosophically they are not religious paintings, but chronicles of the traditions and events that formed Lieberman's life through young adulthood. Because of the cultural milieu in which he was raised, these events necessarily revolved around a religious calendar that dictated both community and

individual activities. Lieberman's paintings became, in effect, the filter through which his life experiences were distilled to create a mosaic of teachings and events that remained most important to him in his older years.

LIEBERMAN AS MEMORY PAINTER

Most of the stories depicted in Lieberman's canvases are recalled from circumstances that had occurred at least half a century before, from his early childhood until his mid-twenties. The pristine clarity with which he remembers these events and teachings is remarkable, especially as he abandoned the study and ritual practice of these traditions in young adulthood, and did not begin to paint until he was almost eighty years old. But as Barbara Kirshenblatt-Gimblett has observed, "Though these childhood experiences in East European towns occupy about a quarter of a lifetime, they expand to fill almost the totality of the memoir."[9]

Lieberman is a memory painter, but with a fundamental difference from such well-known memory painters as Grandma Moses and Mattie Lou O'Kelly. While both these artists have painted images of a past that, of course, cannot be revisited in time, their memories are of places and events that have changed due to the uninterrupted passage of time. Although the artists may recall these scenes with regret or longing, the stability of their memories, happy or otherwise, often translates into scenes of nostalgic recollection. The memory paintings of East European immigrants, on the other hand, often stem from the sense of loss, dislocation, and incompleteness bequeathed by the violent disruption of the homes, villages, and families they left behind.

Jewish artists such as Harry Lieberman also function as "cultural" memory painters. They rely not only on their own memories of specific incidents, but also on the Jewish traditions that have been handed down since biblical times. Their memory paintings become vehicles for the continued transmission of the written and oral traditions of the Jewish faith, as commanded by God: Teach them (these words) to your children and speak of them when you are at home, when traveling on the road, when you lie down and when you get up. (Deut. 6:6).

The rise of a generation of Jewish memory painters and "naïve" artists is a fairly recent manifestation. Folk painting in Israel, for instance, did not appear until the 1950s and is only now receiving the attention it has been accorded in the West. The Jewish artists working in this idiom feel compelled to express themselves by conjuring up images of another life and another land. This compulsion is due, in large part, to the emotional isolation born of mass migrations from countries that had been home to Jews for centuries. But it is also a way of remembering and mourning the family, friends, and strangers who chose to remain in Eastern Europe before World War II erupted.

The paintings speak not only of the temporal dislocation we usually associate with memory paintings, but a physical one as well. These are the scenes that cannot be revisited—the towns, villages, and people of pre-World War II Jewish communities. The paintings, films, photographs, and stories by artists and writers striving to recreate that world represent links to a past that has been virtually annihilated.

Artwork that recalls their East European homes is one of the ways that Jewish immigrants in America try to recreate the Old World in their own lives. Barbara Kirschenblatt-Gimblett writes, "Some individuals create memory objects as a way to materialize internal images, and through them, to recapture earlier experiences."[10] In 1989, the YIVO Institute for Jewish Research explored this notion in the exhibition "Going Home: How American Jews Invent the Old World." For Jewish folk artists such as Harry Lieberman or Ray Faust, a memory painter who emigrated from Tomoshow, Poland, in 1920, "home" is recaptured through the retelling of their stories and heritage in their art. Whereas Ray Faust's paintings are of the concrete attributes of home, community, and the rituals of daily life in a Jewish village, Lieberman's paintings are frequently reflective of another aspect of Jewish life in Poland to which he was privy as a man and a yeshiva student. Lieberman recalls the interior life of the community predicated on its practice of Judaism—the study of Talmud, the stories, the traditions. Both artists painted prolifically and filled their homes with countless depictions of life in Poland. In their "struggle to recover a whole and undamaged world upon which time has no hold,"[11] they recreated the "Old World" in the safety of their contemporary setting through the only means available to them.

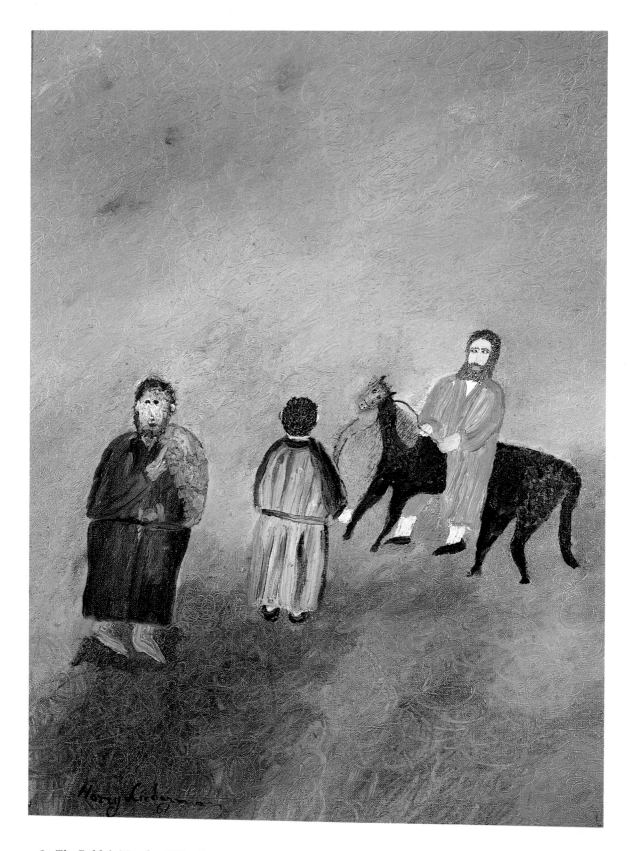

3. *The Rabbi's Mistake*, 1961, oil on canvas, 18″ x 14″. (Private collection) One day, as the rabbi was traveling on his horse and his helper was walking at his side, he came upon a very ugly man. "Look at that man," said the rabbi to his helper, "I do believe he is the ugliest man I ever saw." The ugly man looked at the rabbi and said, "Tell that to Him that made me." ☆ This is a Talmudic aggadah, or parable, derived from the Babylonian Talmud tractate *Ta'anait (Days of Fasting)*.[12] Commentaries on these Holy Days often reflected on the ways of holiness and holy men, as well as on the actual directives associated with fasting. Fasting and other acts of asceticism were used to achieve a higher state of holiness. The Baal Shem Tov discouraged such physical abuses and instead emphasized the achievement of a holy state through moral acts and joy in worship.

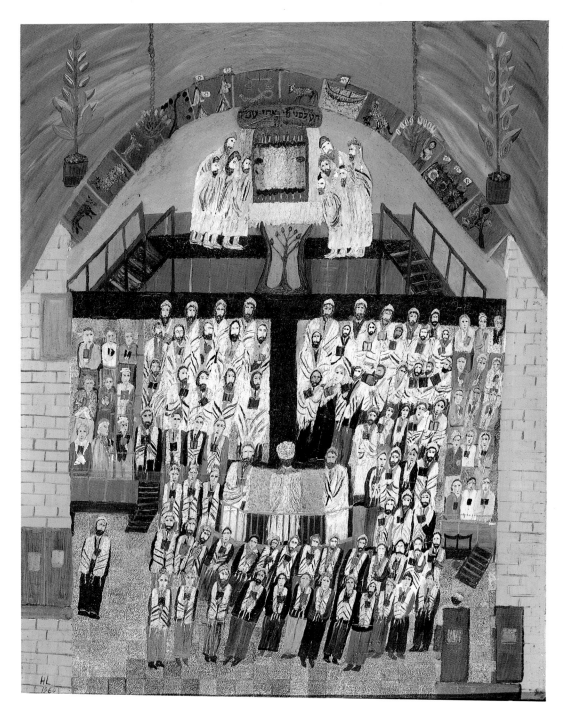

4. *God Hear My Voice*, 1960, oil on canvas, 30″ x 24″. (Collection of David Blake) God Hear My Voice. Lord Our God, hear our cry, spare us. Have mercy and accept our prayer. Turn us to thee, Oh Lord. Renew our days as of old. Give heed to our words, Oh Lord. Consider thou our meditation. May our words and our meditation please thee, Oh Lord, our protector. Cast us not away from they presence and take not the Holy Spirit from us. Do not cast us off in our old age. When our strength fails, forsake us not. Forsake us not, Oh Lord our God, and keep not far away from us. Show us a sign of favor despite our foes. Thou, Oh Lord, hast helped and comforted us. For thee, Oh Lord, we are waiting. Though wilt answer us, Lord our God. ☆ The text that accompanies this painting is a prayer from the Yom Kippur liturgy, the first line of which is drawn from the Shemonah Esreh, a principal part of the daily prayers, while the remaining lines come from verses of Lamentations and the Psalms. Lieberman's visual scheme for this prayer clearly derives from the mizrah and the shiviti, decorative forms usually found in the home or synagogue. Lieberman has depicted the interior of the synagogue he attended in Great Neck, using many of the visual devices found in a late nineteenth-century lithographed mizrah (fig. 49). He translates the compositional elements of the lithograph into architectural and decorative features of the synagogue interior: the central arch becomes the arch over the reader's platform, the columns become the side walls of the synagogue, the urns of flowers become the potted plants that flank the platform on either side, and the emblems of the twelve tribes of Israel form a balustrade from the upper balcony.

5. *The Fruit that Was Brought to Hadrian*, 1962, oil on canvas, 24″ x 30″. (Private collection) One day Hadrian went for a walk in Israel near Tiberias. He passed an old man who was planting a fruit tree. He said, "How old are you old man?," and the old man said, "One hundred years old." Hadrian questioned him, "Old man, old man, why are you planting a fruit tree? Do you expect to live to eat its fruit?" The old man answered, "I hope that I might, but if I do not, my father and his father planted trees; why should I not do so also?" Hadrian said, "As you are so confident that you will live to enjoy the fruit of this tree it would please me very much if you would bring me some of the tree's first fruit." Time passed and the tree bore fruit. The old man took some of the first fruits in a basket and went to Hadrian's palace. At the gate he was stopped by soldiers who asked him why he wanted to see the Caesar? He told them to tell the King that the old man who had planted the tree was at the gate with fruit. When the Caesar heard this, he called the old man in, and when he was given the fruit, he ordered the servants to fill the old man's basket with gold. The soldiers asked him, "How is it that you give the old man a basket of gold for his basket of fruit?" Hadrian answered, "If heaven has honored this man with so many years, why should I not honor him also?" The wife of a neighbor of the old man, seeing the payment he had received for a basket of fruit, told her husband to fill a basket with fruit also and take it to the Caesar. She thought that he too would return with a basket of gold. But when the neighbor came to the King and said that since he had seen how much that fruit was loved by the King and how much it was worth to him, he had a different reception. The Caesar ordered that he be taken to the gate and have the fruit thrown in his face for he had given the gold not for the fruit, but out of respect for the old man. When he returned home and told his wife what payment he had received for his fruit, she said, "Be thankful that the fruit was not large oranges or melons for if it was it might have killed you." I have learned two things from this story. First: no matter how old a man is he should continue to work and to produce, for from this comes the continuity of life; second: no matter how bad a situation is it can always be worse, and one should be thankful that it is better than it could be. ☆ This is a well-known midrash on Ecclesiastes, whose authorship is usually ascribed to King Solomon. Lieberman must have felt that this story was particularly relevant to his own experience. Retirement had disrupted the sense of continuity and tradition that he was only able to recapture once he started painting. This is one of the first canvases to mark Lieberman's progression from simple compositions of single elements to more involved narratives with a cohesive theme and presentation. The palace of the King recalls the "Tent of Meeting" in which Moses communicated with God in the desert after the Exodus from Egypt, while the houses below are clearly wooden shtetl structures. The scattered apple trees recall Solomon's Song of Songs 2:3, "As an apple tree among the trees of the wood, So is my beloved among the sons." A midrashic interpretation suggests this is a reaffirmation of the oneness of God. As the only fruit-bearing tree among a forest, so God is the only power among a forest of powerless deities.[13]

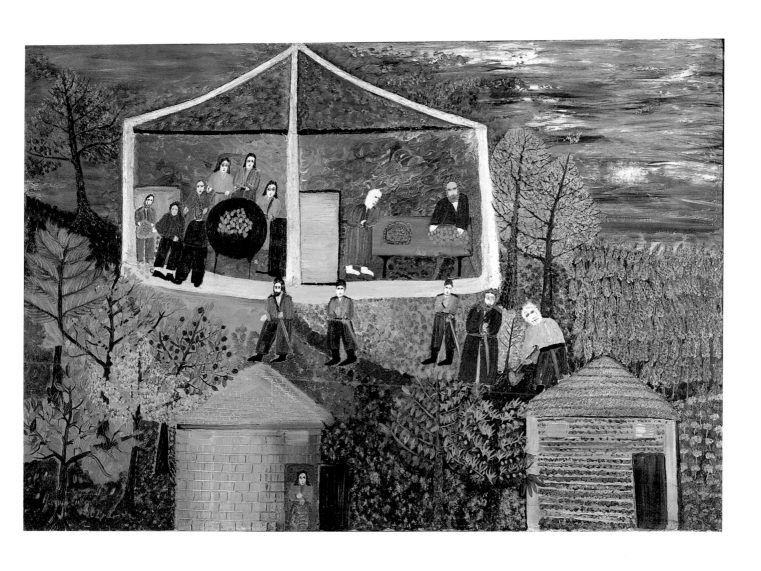

6. *I Am the God*, c.1968, oil on canvas, 30″ x 40″. (Courtesy the Morris Gallery, New York) The fifth commandment states that you should honor your father and mother. However, this creates a problem. If your father or mother tells you to pray to another god, must you honor them by obeying? An old Talmudic parable tells of three friends who went on a journey together. One was an astronomer, one was a doctor, and one was the owner and operator of the balloon taking them on the journey. One day the astronomer with his telescope saw a crowd gathering miles away. The balloon owner took the three men there to see what was happening. They discovered that the crowd was lamenting the terrible sickness of the princess of their country. The doctor went to the princess, recognized her sickness, and cured her. The princess was so grateful to the three strangers that she agreed to marry one of them, but which one? "If it wasn't for me, we would never even have known you were sick," said the astronomer. "But if it wasn't for me, we would never have arrived in time to save you," said the balloonist. But the princess decided to marry the doctor. "It was the doctor who did the healing, the others were merely instrumental. The astronomer might just as well been some traveler with the news and the balloonist could have been some horseman. But if the doctor had been anyone else but a doctor I would not be alive today." Thus the theological problem was also resolved. The first commandment, which says "I am your God," is the basis of the entire religion. The others are merely incidental. If another commandment is ignored the religion suffers, but if the first commandment is broken the religion is destroyed and the remaining commandments are worthless. ☆ Israel is often allegorized as the figure of a princess or a bride. In this parable, the princess's illness can be interpreted as a crisis of faith. When she chooses as her husband the doctor, whose nature is immutable, she is reaffirming her belief in God. The literal events of this story are confined to six boxes on the upper left side of the composition, while the theological question that is posed and answered is shown below.

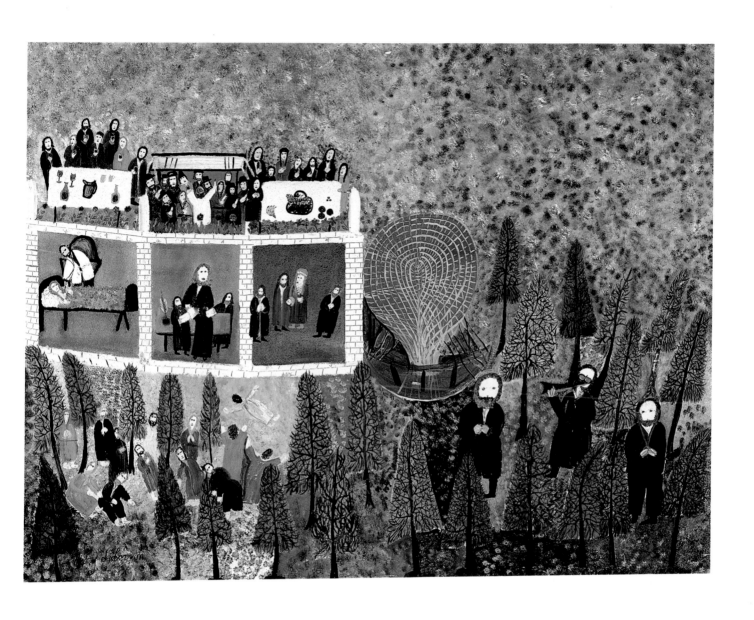

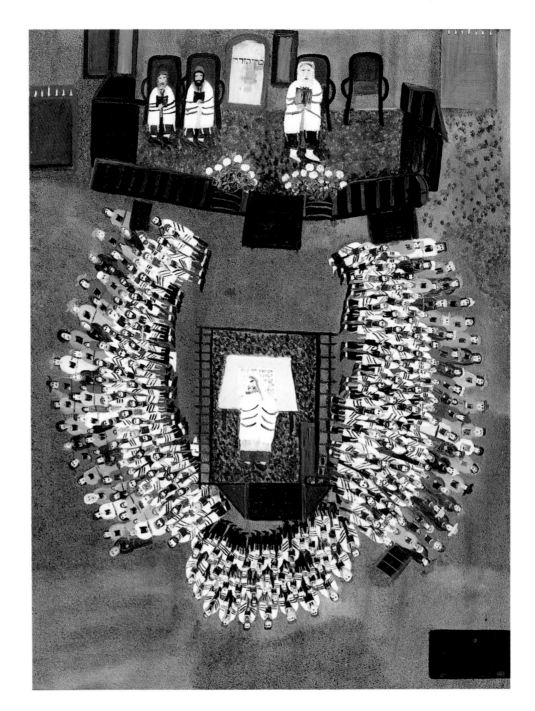

7. *Traditional Synagogue Scene*, c.1966, oil on canvas, 40″ x 30″. (Collection of Dr. and Mrs. Stephen Hirschberg) This painting is an accurate depiction of the interior of an Orthodox synagogue. Synagogues are viewed as temporary sanctuaries, in use only until the restoration of the Temple in Jerusalem that was destroyed by the Romans in 70 CE. The requisite components of the synagogue are the Torah scrolls, which are housed in an "ark," and considered more holy than the building itself; and the reader's platform and table known as the "bimah." The bimah is frequently found on a raised platform surrounded by a railing. Conceptually, this raises the words of the Torah above the congregation and out of the realm of the everyday. The Torah scroll rests on the table while the portion of the service is read aloud. When the bimah is situated in the center, as in this case, the congregation forms a circle around it on three sides. The reader faces the ark, which is situated on another platform at the end of the east axis and protected by a balustrade. This enables the reader to face east toward Jerusalem as the Torah text is read. The elders of the congregation and the cantor might sit on the platform at either side of the ark, thus completing the circle around the bimah. Polish synagogues often featured long, narrow windows, as shown here, and shelves high above the heads of the congregation. This allowed the placement of a row of candles for additional light without fear of setting fire to the wooden structure of the synagogue. Women are separated from the men in Orthodox synagogues, and in this painting Lieberman situates the two rows of women on a balcony reached by the set of steps at one end of each group.

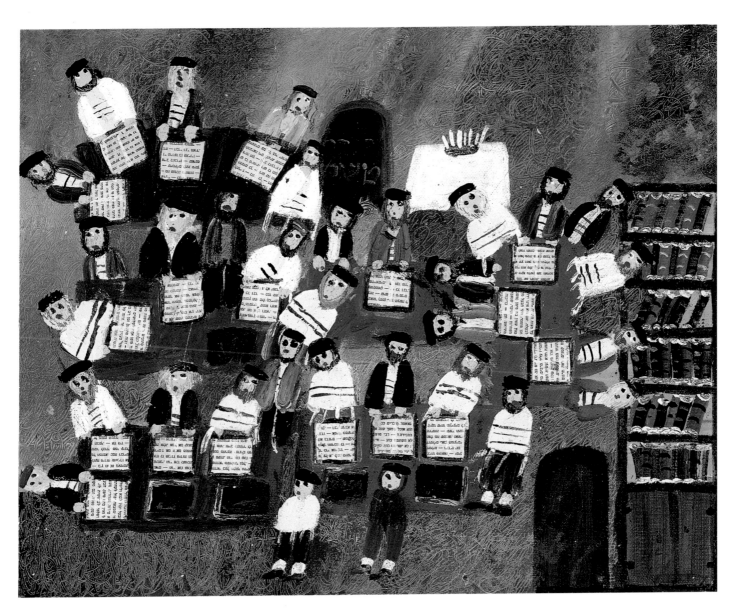

8. *Yom Kippur*, 1981, acrylic on canvas paper, 16″ x 20″. (Private collection) This is a scene inside a Hasidic shtibl, or study house, on Yom Kippur, the Day of Atonement. The men are wrapped in their prayer shawls and sit around rows of tables. The ark containing the Torah scroll is marked "Torat Moshe," referring to the Five Books of Moses. This interior shows the variety of purposes shtiblekh served. They functioned as study rooms, rabbis' offices, and places of worship. For poor students, they offered refuge for the night. The prayerbooks open before each of the men were cut by Lieberman from Jewish newspapers.

CHAPTER I

EAST EUROPEAN IMMIGRATION TO AMERICA

Since its beginnings, America has represented a harbor of hope, safety, and freedom to immigrants from all walks of life. To many Jewish immigrants, the "goldene medine," or golden land, offered a cherished dream of surcease from the poverty, persecution, and ignorance they had too often found in their own countries. Among the thousands of Jews who emigrated to America yearly from the mid-nineteenth century until the early-twentieth century, some would achieve fame, some would find only a life of drudgery as relentless as the one they had left behind, and some, like Harry Lieberman, would find both happiness and success.

When Harry Lieberman emigrated to America from Poland, he was leaving the cloistered life of a Hasidic Jew in a community of Hasidic Jews. Although internal religious conflict was minimal, a disapproval of Hasidism by traditional Orthodox Jewish communities (mitnagdim) was and had been a constant concern since Hasidism was founded in the eighteenth century. Also, the secular movement known as the "Haskalah" or "enlightenment," was increasingly causing Jews to question the closed religious life imposed by the shtetl. Lieberman was undoubtedly influenced by this movement that supported his own questioning nature. As he later said, "A thinking man thinks. My eyes are open to see, my ears are open to hear, my nose is ready to breathe. So little by little I started to ask questions."[14]

Although Poland had offered Jews one of their longest periods of calm and greatest civil freedoms since the Diaspora began, the horrendous massacres of the mid-seventeenth century in which over two hundred thousand Jews were killed, anticipated the renewed pogroms that would ensue in the wake of Tsar Alexander II's assassination in 1881. Lieberman was born just as the lenient tendencies that had been manifested by Alexander II were being replaced by a period of increasingly violent aggressions against Jews throughout Russia, Poland, and other areas of Eastern Europe. The rising repression and acts of violence against Jews were leading to greater and greater numbers of applicants for emigration, giving rise to a mass exodus over the next hundred years that author Ronald Sanders has likened to the biblical Exodus from Egypt.[15]

The Polish and other East European immigrants of the nineteenth century were generally less welcome in America than their German and Sephardic predecessors had been. There were fears that refugees arriving from the unstable Russian territories were either bomb-throwing radicals, anarchists, or uneducated, uncouth riffraff, all of whom spoke a bastardized language. The established Jewish communities perceived the new immigrants as a threat to the hard-earned stability and high reputation they had struggled to achieve. Moreover, many of the new arrivals were more deeply entrenched in an Orthodox Jewish way of life than previous generations of immigrants had been. From the late 1860s on, these new Jewish immigrants emerged from their closed communities in growing numbers and were confronted upon their arrival in America with an alien culture, an alien language, and a Judaism that was vastly different from its insulated practice in Eastern Europe.

The Sephardic and German Jews of the earlier periods of immigration, from Colonial times until the mid-nineteenth century, had been eager to assimilate to American life. In time they became an integral part of the mercantile life of Colonial Newport, New York, Philadelphia, Charleston, and Savannah. During the nineteenth century, they were among the commercial pioneers of the expanding Middle and Far West.[16] In their desire for assimilation into the American

mainstream, they preferred to be called "American Israelites" rather than Jews. Reform Judaism, which critics called, "the merest variation on some American Protestant denomination,"[17] emerged originally from Germany and took root in this generation of Jewish immigrants eager for acceptance.

In general, the immigrants of the late nineteenth century were not unskilled in the crafts and trades that formed the mainstay of life in East European towns and villages, but their sheer numbers meant that most of them could not be absorbed into their former professions in America, and few new avenues were open to them. In the face of these obstacles, the instinct to stay together and form their own homogeneous communities was strong. Immigrants settled near other immigrants from the same home towns and established "landsmanshaftn," or mutual-aid societies, and synagogues that served a constituency from a particular area.[18] These conditions also encouraged the survival of Orthodox Jewry without fear of outside curiosity, influence, or reprisals.

Before the East European immigration of the 1870s, there had not been a specifically Jewish area in New York City. The new arrivals formed the first fixed Jewish community on New York City's Lower East Side, attracted by the garment trade that had already been established by previous generations of German Jews. The Jewish immigrants had strong traditions in the needle arts and continued to ply their trades in their new homeland. Grand Street, east of Broadway, became an area of department stores, and Canal Street became the seat of the wholesale suppliers to the trade. By the 1890s, the area east of the Bowery between Houston Street and East Broadway was predominantly Jewish, replacing the earlier Irish communities that moved to the south and the east along the East River, and the German communities that moved above Houston Street (fig. 9). This followed patterns established in Eastern Europe where the Jewish settlements were usually located near trade centers and businesses; their non-Jewish neighbors often living in the outlying, more suburban areas.[19]

The light-manufacturing industries represented the immigrants' best hopes for economic survival upon their arrival in America and a stepping-stone to advancement or owning their own businesses. But the overriding interest of this new Jewish community remained life in the Old World. A vigorous dialogue between Jews in America and the families they had left behind ensued in private letters and in Yiddish newspapers such as the *Jewish Daily Forward*, which published news from overseas, personal letters, announcements, and photographs from the Old World.

9. *Orchard Street Looking South from Hester Street*, Photographed by Byron, New York, 1898. (The Byron Collection; Museum of the City of New York) This photograph was taken several years before Leiberman came to America. The Lower East Side had become one of the most congested areas of the world by 1906, the year he arrived. The streets are lined with shop signs in English and Hebrew and a variety of goods and services are offered by both street peddlers and enclosed shops.

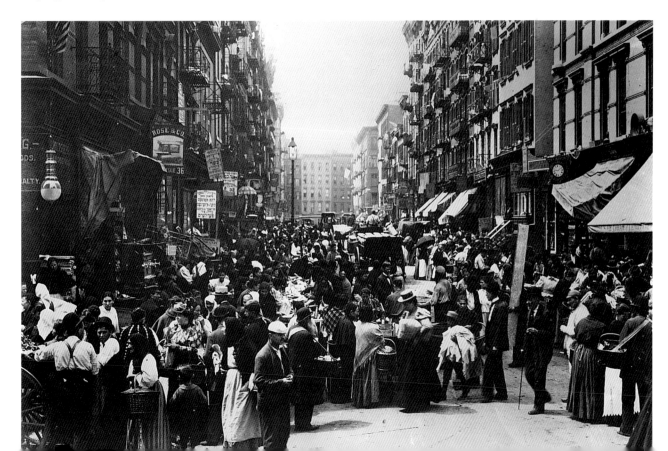

CHAPTER II
FROM POLAND TO AMERICA

GNIEWOSZÓW

Harry Lieberman was born in the small village of Gniewoszów, Poland. The village became a Russian territory with the partitioning of Poland that took place at the end of the eighteenth century (fig. 10). Gniewoszów was originally founded in 1693 by a local landowner, Ian Gniewosh, and chartered in 1712 by Augustus II. It was in the "voivodeship" (jurisdiction) of Radom in the Kielce district. Gniewoszów and its neighbor Granitz were intended primarily as trade centers and designed to accommodate fairs and shops. With the establishment of Warsaw as the Polish capital, new trade routes were formed along the Vistula River, and the two towns thrived. By 1880, there were ninety-three houses, a post office, a county judicial seat, a district school and, together with Granitz, over two thousand inhabitants, including approximately three hundred Jewish families.[20]

The town was comprised primarily of single-level wood structures (fig. 11). There was no running water (fig. 15), no plumbing, and no electricity. Even the wealthiest families shared their homes with relatives, with a shop or other business concern in the front, and two rooms for sleeping in the back. The businesses and trades were usually owned and operated by the Jewish residents who lived in the town, while the non-Jewish Poles lived on and owned the outlying farms (fig. 12).

In September 1940, the village became a ghetto and a transfer point for Jews from Warsaw, Lodz, Radom, Pulawy, Krakow, Przytyk, and other towns. Eventually, more than seven thousand people were confined to Gniewoszów before being transfered to the ghetto in Zwolen and to the Deblin and Treblinka annihilation centers. On November 15, 1942, one thousand people were deported from Gniewoszów to Treblinka.[21]

Jack Kugelmass and Jeffrey Schandler have written that since the Holocaust, "...the sense of an Old World home has become more abstract," and that Americans who return to Eastern Europe..." are seeking a home that they themselves have never known."[22]

Members of Lieberman's family have returned to Gniewoszów, better equipped than most, perhaps, through a familiarity with the shtetl learned from Lieberman's paintings and through the "yizker-bukh" (memorial book) that represents the living memories of Gniewoszów's survivors. Approximately six hundred such memorial books have been published since the end of World War II documenting "shtetlekh," the small towns throughout Eastern Europe where most Jews lived. These books have been created from the first-hand memories, photographs, and ephemera of immigrants and Holocaust survivors. According to Jack Kugelmass and Jonathan Boyarin, the very name "yizker-bukh" unconsciously underscores the purpose of these volumes as a substitute for the traditional memorial service that so many of the dead of World War II never received.[23]

10. *Poland in the Time of the Partition*, 1815–1914.
(Courtesy the YIVO Institute for Jewish Research,
New York) At the end of the eighteenth century, Poland
was partitioned between Austria, Prussia, and Russia so
that it no longer existed as a separate political entity.
Lieberman's town of Gniewoszow, beside the Vistula
River, became part of the Russian annexation in the
Pale of Jewish Settlement.

11. *The Old Marketplace on Market Day in Krzemie-
niec*, Photographs by Alte Kacyzne, 1925. (Courtesy
the YIVO Institute for Jewish Research, New York)
The shtetl of Krzemieniec was one of the oldest
settlements in Eastern Poland. On market day, peasants
from the surrounding countryside brought produce to
the town in exchange for manufactured goods from the
Jewish community that lived in the town. This scene
is of the older section of the shtetl. A comparison with
the wooden architecture of Lieberman's depictions
illustrates the accuracy with which he recalled these
scenes so many years later.

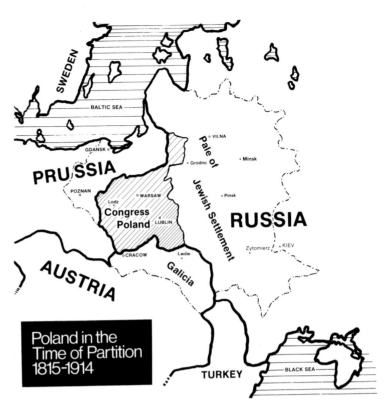

Poland in the
Time of Partition
1815-1914

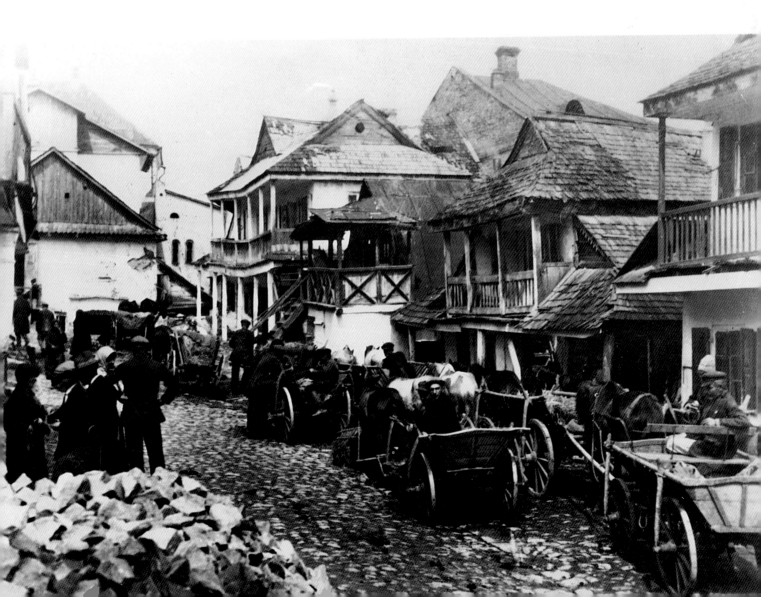

12. *The Marketplace*, 1961, oil on canvas, 30″ x 40″. (Collection of Helen Popkin) This painting reflects the vitality and diversity of the marketplace in a Polish town. The variety of goods and services included pickle barrels, fabrics, meats, breads, tailoring, and cobbling. Some shops were housed indoors, while others peddled their wares on tables set up outside. The wooden structures in this painting reveal private residences, places of business, and shtiblekh. In the wide, unpaved thoroughfare surrounded by buildings Jews, Poles, and Cossacks throng and shop, trading livestock, goods, services, and stories.

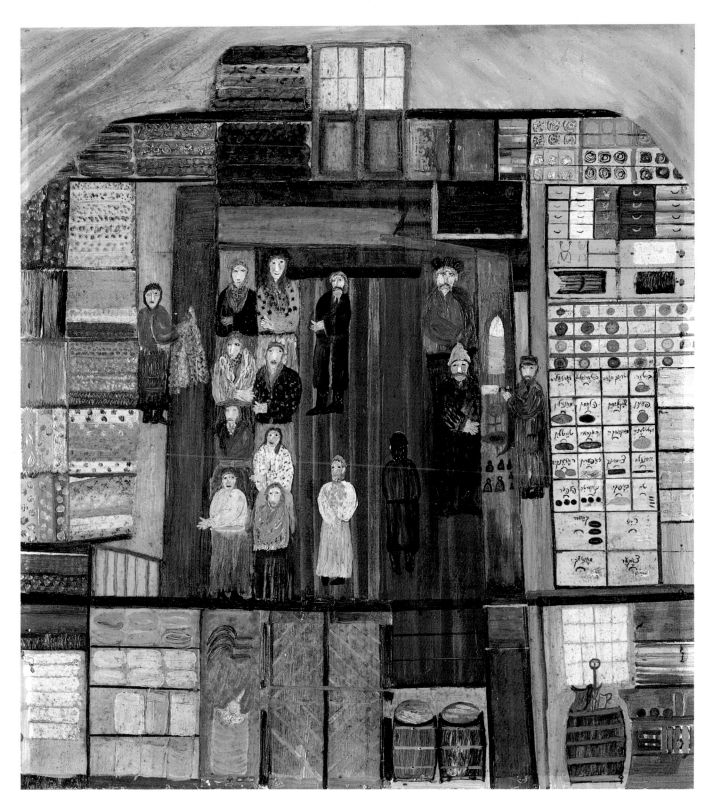

13. *My Father's Store*, c. 1961, oil on fiberboard, 28″ x 25½″. (Hirshhorn Museum and Sculpture Garden, Smithsonian Institution, Washington, D.C., Gift of Joseph H. Hirshhorn, 1966) Lieberman has rendered the interior of his father's general store as he remembered it after the passage of at least sixty years. Each sectioned case is neatly labeled in Yiddish, offering a variety of fresh and nonperishable goods, such as lemons, raisins, coffee, tea, sugar, and rice. The design of the store is reminiscent of the small groceries, and fruit, nut and candy stores that flourished on the Lower East Side of New York City during the period of mass immigration. Many Jewish tavern proprietors in Eastern Europe also served liquor, often to peasants and Cossacks. This practice, while long established, was disapproved of by the local government and the sector of the Jewish population that did not have to depend upon such trade for its livelihood. Here, too peasants drink vodka at the counter while Lieberman's father stands behind the bar.

14. *Birth of a Child* (Psalm 121), 1961, oil on canvas, 20″ x 16″. (Private collection)

A Song of Degrees

I lift up my eyes to the mountain;
 whence shall come my help?
My help is from the Lord,
 the maker of heaven and earth.
He will not suffer thy foot to slip;
 Thy keeper doth not slumber.
Behold, He slumbereth not and He sleepeth
 not—the keeper of Israel.
The Lord is thy keeper
 The Lord is thy shade, He is on thy right hand.
By day the sun shall not strike thee
 nor the moon by night.
The Lord will guard thee against all evil;
 He will guard thy soul.
The Lord will guard thy going out and thy coming in from this
 time forth and forevermore.

"This picture represents the precautions against evil entering a male child before circumcision puts him under the protection described in the psalm." ☆ One of the deepest criticisms levied against Polish Jewry by the Haskalah, was the superstitious nature of the uneducated. It was said, "There is no country where the Jews are as much given to mystical fancies, devil-hunting, talismans, and exorcisms of evil spirits as they are in Poland."[24] It was a commonly held superstition that until he was circumcised, a male child was prey to the demon Lilith. Amulets containing Psalm 121 and other writings were used as protection against Lilith, who was constrained to leave a child unharmed when she encountered her name. When Lieberman was eight, he and other cheder students stood at the bedside of a woman who had just given birth to a son. They recited this prayer to keep Satan from reaching the newborn baby. He remembered that they also posted Psalm 121 on the windows and doors to prevent Satan from entering, and continued to do this until the baby was circumcised.

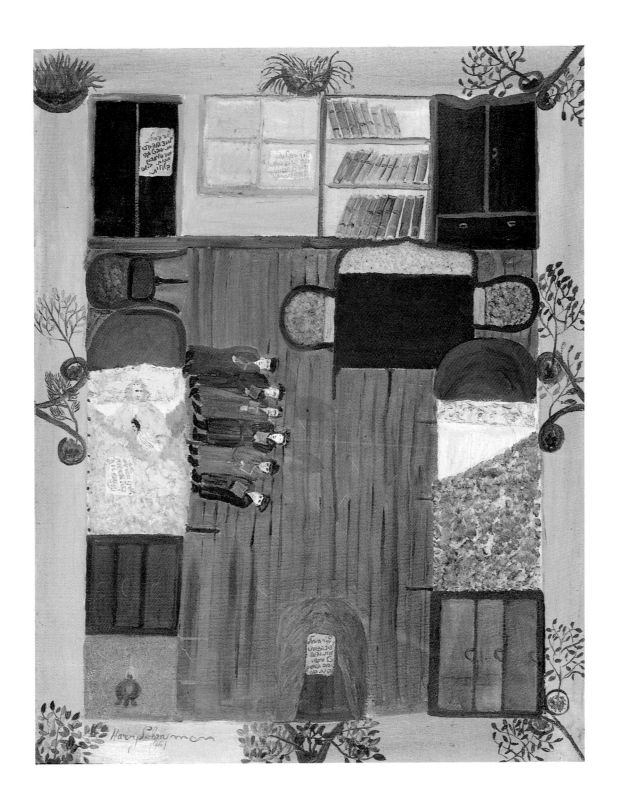

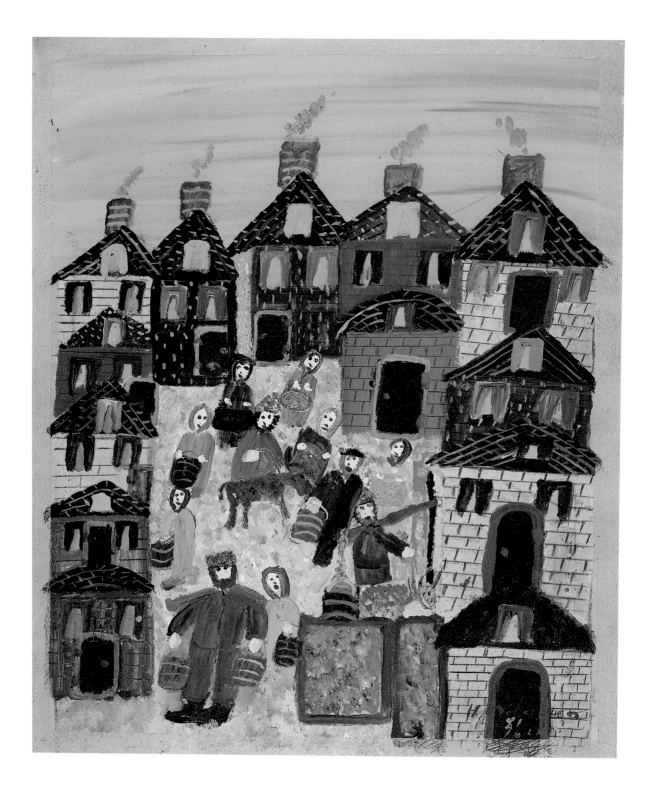

15. *The Water Carrier*, 1981, acrylic on canvas, 24″ x 20″. (Private collection) The water carrier from Gniewoszów. Etchu Meyer, the water carrier, earned his living carrying water. In Gniewoszów, the hometown of the artist, the only water for the town lay at the bottom of the valley, some distance from the town. The common people would carry their buckets to the "brenrer," a brick-walled well, to get their daily supply. However, the wealthy did not have to partake in this tedious, heavy chore. Etchu Meyer, the water carrier from Gniewoszów, earned his living carting water from the well to the homes of the wealthy. For this service Etchu Meyer received twenty-five cents a week. ☆ Lieberman rarely identified his paintings as actual depictions of Gniewoszów. This painting recalls one of the familiar characters of the shtetl, the water carrier, who appears in many of Lieberman's canvases. By repeating his name and occupation several times in this text, "Etchu Meyer, the water carrier from Gniewoszów" becomes a formulaic invocation that carries its own powerful associations. Such characterizations are reminiscent of anecdotal and descriptive chapters in yizkor books that not only capture the flavor of life in Eastern Europe, but serve as testimonials to figures of the shtetl.

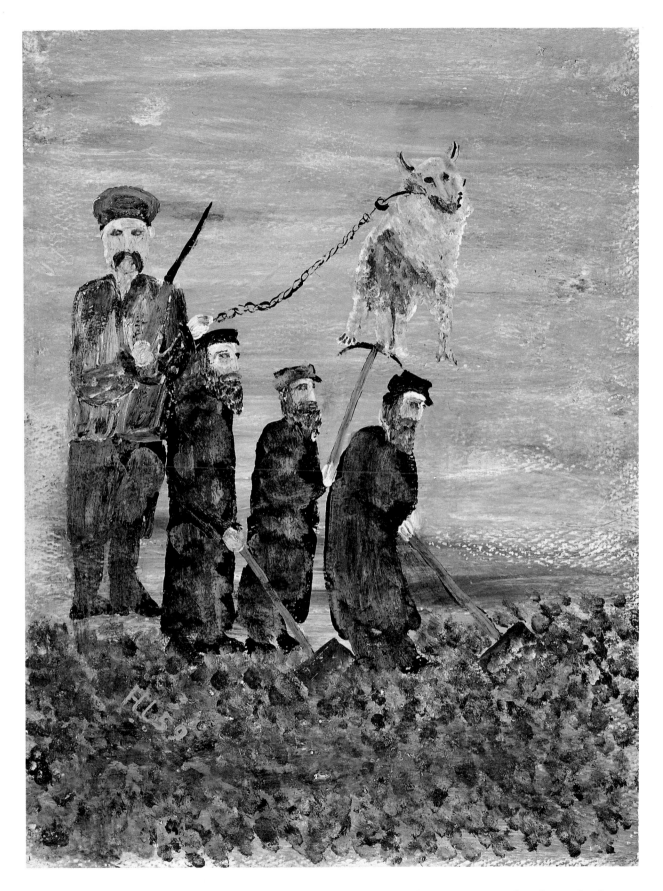

16. *Dig Your Own Grave*, 1959, oil on paper, 11½″ x 8¹¹/₁₆″. (Hirshhorn Museum and Sculpture Garden, Smithsonian Institution, Washington, D.C.; Gift of Joseph H. Hirshhorn, 1966) This small painting executed in a grim, pebbly texture of grey, black, and white, is a horrifying indictment of Nazi barbarism. Three Orthodox Jews are forced to dig their own graves. The Nazi guard stands over the three frail, stooped figures, wielding a gun and holding a large German shepherd by its leash.

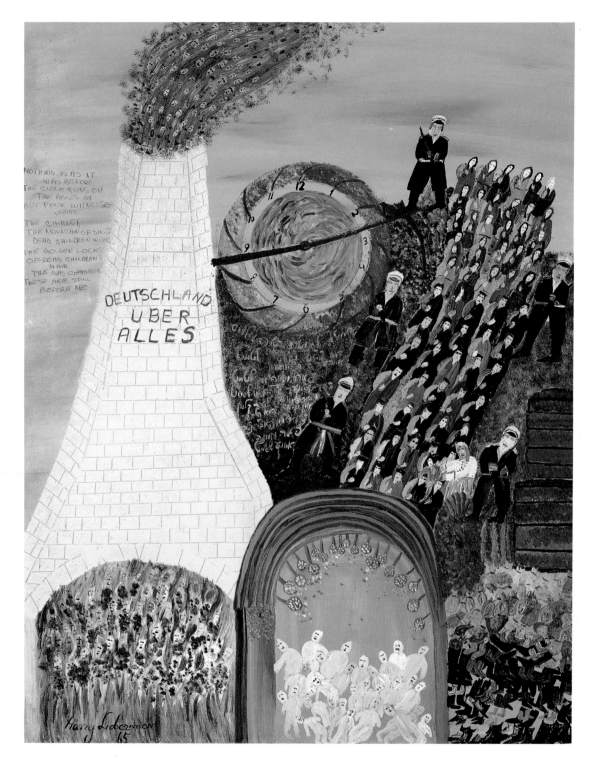

17. Untitled (Nothing Is as It Was Before), 1965, oil on canvas, 30″ x 24″. (Collection of Celia Thaxter Hubbard)

Nothing is as it was before
The clock runs on/Time Passes by
But four witnesses/remain
The chinmey/the mountain of shoes
Dead children wore/the golden locks
Of dead children's/hair
The gas chamber
These are still before me

Lieberman's painting of a concentration camp is a raw indictment of the atrocities perpetrated during the Holocaust. At the front of the line of Jews being forced to their deaths, a woman, possibly a nurse because of her white cap and blouse, hands a baby, too young to walk by itself, into the gas chamber.

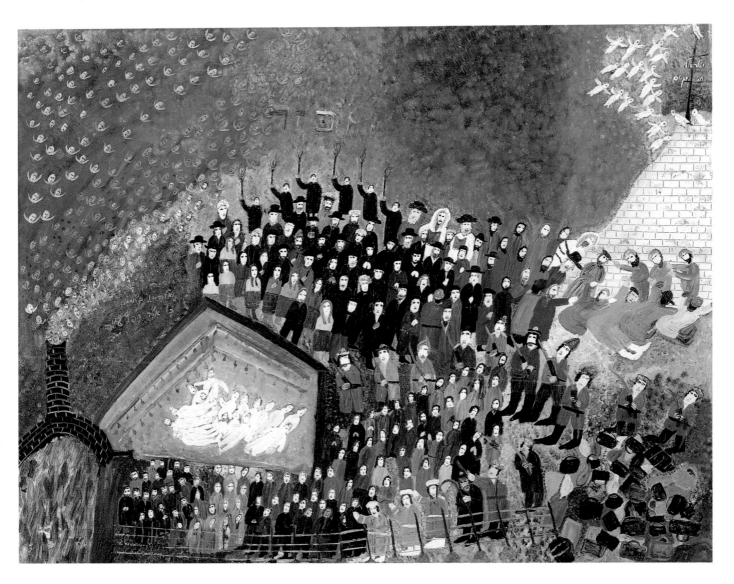

18. *Yizkor (Remembrance)*, c.1969, acrylic on canvas, 30″ x 40″. (Collection of Erica Popkin) At first glance, this scene with its muted colors and wispy shapes seems to be a pretty painting with crowds of people. On second glance, one realizes that this is, in fact, a scene of a concentration camp and the crowds of people are Jews being led to their deaths in the gas chambers. A growing pile of purses and personal belongings mounts on the lower right. Soldiers stand guard as the prisoners, behind barbed-wire fences, are led to the chamber with the shower heads above. A pile of white bodies is ready for removal so that the next group can be marched in. As the bodies are cremated in the huge furnace, their souls fly by the hundreds through the chimney flue and rise into the heavens. A line of six men in the back hold black yahrzeit torches to commemorate the six million Jews who died during World War II. The torches illuminate the word yizkor (remembrance). At the far right, ghost-like angels emerge from the Wailing Wall and a "Tree of Life" grows from the top of the Wall, inscribed with the words, "Yisrael Chai Va Khayam" ("Israel Will Live Forever").

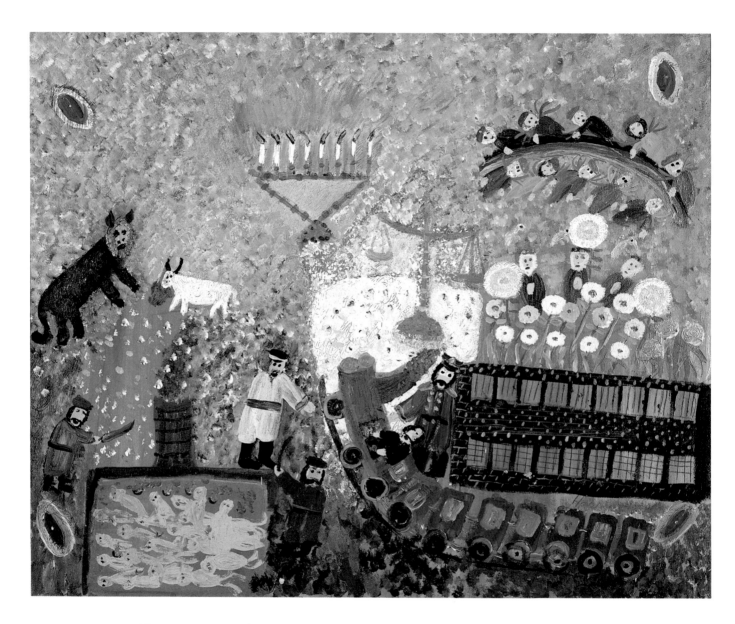

19. *World Peace*, c.1980, acrylic on canvas, 24″ x 30″. (Private collection) This is one of at least two paintings with the theme "live and let live." The paintings are divided into eight sections that refer to symbols of peace, such as the rainbow, the light of the Temple,[25] the scales of justice, the wild beast lying down with the lamb, and political strides that have been made toward peace, such as the Camp David Accords. Lieberman writes, "People ask me who I am to start in on such as a subject at my age. The answer is that I have lived 103 years, and I have observed over the years and heard the cries of the millions who were killed during all the wars. I do not want to take the cries that I have heard with me to my grave. I want the public to know and see and hear and feel the same cries of the millions which I have collected…Let us all start to do what the prophet said, what was started at Camp David, sit and talk and work together for peace. I know you'll say that I am a dreamer. First, it is a very good dream and second, if we all work together, we can make this dream a reality."

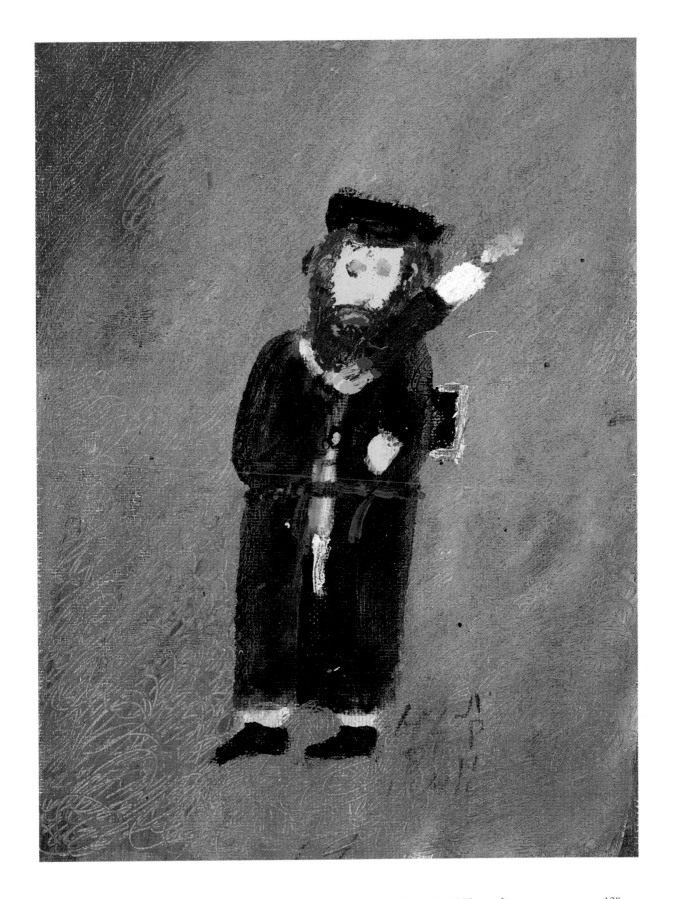

20. *My Father Holding a Cigarette (He Was 87 When Hitler Killed Him)*, c.1982, acrylic on canvas paper, 12″ x 9″. (Private collection) Near the end of his own life, Lieberman recollected his father as a young Hasid in his prime. In his memory, he associates his father with smoking and this is illustrated by the enormous cigarette that overwhelms the figure. Aaron Liebhaber was shot by the Nazis when he was unable to keep up with a forced march. This small painting is one of Lieberman's rare direct references to his parents.

BIOGRAPHY

Naftuli Hertzke Liebhaber was one of thirteen or fourteen children born to Aaron Liebhaber and his wife, Esther Malcah Liebhaber. It was not until his arrival in America that his name was changed from Liebhaber to Lieberman and from Hertzke to Harry. Years later, however, it was again as "Naftuli Hertzke" that Lieberman chose to sign his paintings in Yiddish.

Little is known about Lieberman's life in Poland. He was raised in the Hasidic tradition; his father, who owned a general store (fig. 13), was descended from a Hasidic rabbi of local fame. Some biographical insight is offered through Lieberman's own explanations of his paintings. In the text for the painting, *The Seven Stages: The Artist 103 Mature*, Lieberman wrote, "This painting is the story of my life from the beginning until 103." The text chronicles his life in Poland from age nine, when he entered cheder, or religious school, to age eighteen, when he entered the yeshiva. At age twenty-nine, he emigrated to America, where his secular life began and continued until 1956, when he rediscovered the value of a religious life. He concluded the text by writing, "I made this painting to show that a person's age is not a curse. I am now 103 and capable of experiencing and communicating the beauty of the world. I want everyone to see it. I want to emphasize that I am 103 years mature, not old—because maturity comes with age."

Lieberman's marriage had been arranged by his own parents and the parents of the prospective bride when he was quite young. His father was concerned with finding good homes for his many children, and one way to provide for their future was through marriage. His father returned from a trip to Radom, sixty kilometers away, and announced that he had found a wife for his son. Lieberman was a slight man, being only five feet four inches tall and slender. His parents felt that he had been a sickly child and thought he was still too frail. They wanted him to marry into a family that would always keep food on the table, so Lieberman was married to a shohet's daughter. He was then trained as a shohet (ritual slaughterer) himself, and he practiced this profession until he came to America. He and his first wife had three children, the last having been born shortly before he emigrated to America. The marriage was not a happy one, however, and ended in divorce before he left Poland.[26]

In 1906, Naftuli Hertzke Liebhaber made his way to Hamburg, Germany, along with thousands of other Jews, where he either hoped to obtain steerage passage or already had tickets booked on one of the commercial steamships that routinely transported

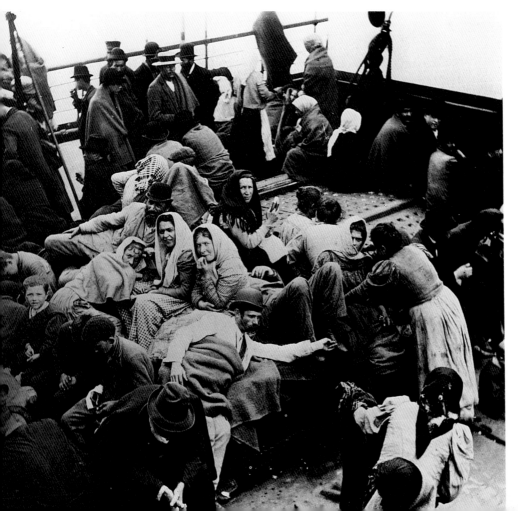

21. *Immigrants on S.S. Westerland*, photographer unknown, c.1890. (Museum of the City of New York) Steerage passengers to America lived on overcrowded decks and below deck without accommodations for weeks on end. Here, passengers huddle under blankets while they try to protect themselves against the elements.

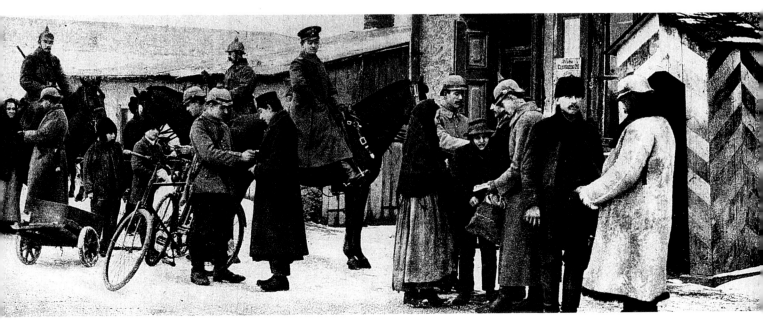

22. *Checkpoint in Czestochowa*, 1914. (Courtesy the YIVO Institute for Jewish Research, New York) Emigrants from Eastern Europe traveled along well-trodden routes from their homelands to ports of debarkation. Hamburg was a port often used by emigrants from Russia, with checkpoints situated all along the way to the final destination. In this photograph German guards search the travelers for smuggled food.

23. *S.S. Pretoria*. (Courtesy the Steamship Historical Society Collection, University of Baltimore Library) In 1906, Lieberman obtained passage on the steamship *Pretoria* of the Hamburg-American line. This was one of a number of commercial steamships that routinely transported emigrants from Hamburg to America.

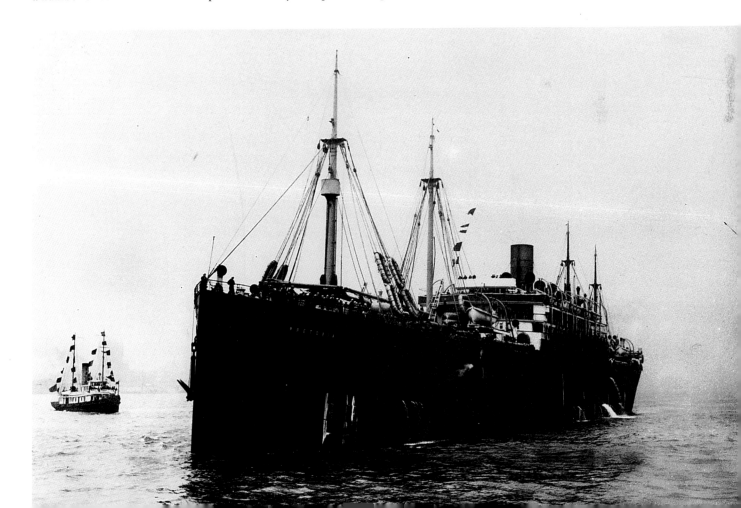

emigrants to North American receiving ports (fig. 21). The Hamburg route was favored by emigrants from Russia, but arriving safely in Hamburg often seemed like a major feat in itself. There were numerous checkpoints along the way where officials had the power to terminate the journey at any time (fig. 22). The Hamburg Council met each hopeful emigrant and checked his records, tickets, health and money. Those who passed this inspection were then sent on to one of a number of chartered lodging houses that offered overcrowded conditions and meager kosher meals. These inhospitable surroundings might prove to be home for several weeks to those without steamship tickets, as passage was granted on a first-come, first-serve basis.

On July 13, 1906, Lieberman boarded the S.S. *Pretoria* (fig. 23). He arrived in New York on July 28th. The passenger list for the *Pretoria* indicates that Lieberman paid his own fifty-dollar passage and was received by Hirsh Kormann or Konmann.[27] Improbably, Lieberman entered his occupation on the passenger list as "painter."

Lieberman recalled that before he came to America he had already graduated at the top of his yeshiva class, was wearing a shtreimel (a fur-brimmed hat worn by Hasidic men), and was married. He said later, "As much as it was misery to live there [Gniewoszów], it was misery to leave."[28] Although he spoke no English, he adjusted to life in America quickly, changing his name to Hercky or Harry Lieberman, and soon shedding the Orthodox Jewish traditions of his life in Poland. Lieberman once said, "That's the difference between Europe and America. In Europe, the whole world is religious. Here, everything depends on you."[29]

One of Lieberman's first jobs came through a "landsman," a person from the same town or region in the Old Country. Lieberman protested that he had no "language" but was assured that he would not need to speak. He became the cashier in a bakery in the Jewish section of Harlem. On Rosh Hashana, the Jewish New Year, the friend gave him tickets for the holiday service, but Lieberman did not understand what they were for; in Poland tickets were not needed for services—everybody attended. When he arrived at the synagogue, "A big fat fellow was at the door. He says to me, 'Ticket. Ticket.' I didn't know what he meant. He pushed me by the shoulder. 'Get away greenhorn.' This push away broke my heart. The beginning of the Jewish New Year and I can't go into the synagogue! This gave me the first push, and little by little I pulled away entirely and left the rabbinical stuff to the rabbis."[30] Lieberman did not attend synagogue for the next fifty years.

When Lieberman had been in America a short time,

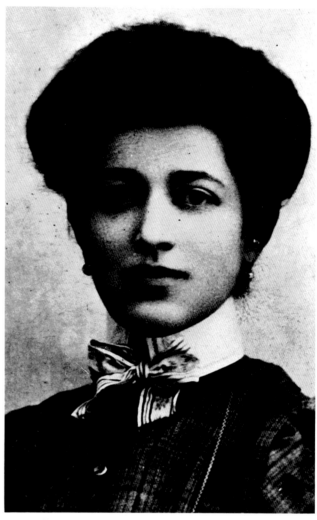

24. Sophie Korman, photographer unknown, New York, c.1910. (Collection of the artist's family) This photograph was taken of Sophie Korman, Lieberman's future wife, shortly after she came to America. She was married to Harry Lieberman in 1911.

he paid a man twenty-five dollars to teach him to be a clothing cutter, "A not so good cutter," in Lieberman's own assessment (fig. 28). After a month's free apprenticeship with a company on the Lower East Side, Lieberman was finally eligible to be paid, but found that he was expected to work as a messenger rather than a clothing cutter. Cutters in those days carried their own tools—a long cutting knife, a short knife, and a stone—all wrapped together in a rag. Lieberman tried to find day work, with varying success. In 1910, the New York State census indicates that he had been working as a cutter for four years and had been out of work for ten weeks during the previous year.

Lieberman was then lodging with Morris Fuchs (the

proprietor of a button factory) and his family on East 9th Street. In 1911, Lieberman moved to 264 Second Avenue with his second wife, Sophie Korman (fig. 24). His father-in-law, a shoe peddler, noticed that Ludlow Street was lined with stationery stores. He suggested that since the owners of local candy stores had to come to Ludlow street to order their business cards and receipt books, Lieberman could sell them candy wholesale at the same time. With the five hundred dollars that he had saved since coming to America, Lieberman had business cards printed and walked a ten-block radius distributing his cards to the candy stores. His business thrived, and a few years later he received a letter from the Wholesale Confectioners Association inviting him to join their organization. When he did not respond, the secretary of the Association visited his store and recommended that Lieberman become a member. However, the Association wanted to charge Lieberman more for each box of candy than he was selling them for, and he refused to join. The next month, Lieberman found that no one would sell candy to him, except Hershey's Chocolates, but he would not be coerced into joining. During the National Recovery Administration (NRA) in the 1930s, the candy industry established code prices with which Lieberman complied. When he realized that candy merchants were secretly discounting their merchandise, however, he returned to his pre-NRA prices, advertised what he was doing, and sued to have the NRA overturned. The NRA was eventually successfully challenged in a subsequent case.

On May 9, 1917, Lieberman filed his Declaration of Intention to become a citizen of the United States. Five years later, on March 16, 1922, he filed a Petition for Naturalization with the Supreme Court of New York State. By this time he was residing at 5022 17th Avenue in Brooklyn with his wife, their two daughters, and his wife's daughter from her first marriage. Sometime during this period, Lieberman's youngest daughter from Poland also came to live with them. So they were now a family of six.

There are indications that Lieberman had tried to become naturalized at an earlier date. His request was denied, possibly due to a misplacement of his Certificate of Arrival. But by August 1, 1922, all obstacles had been cleared, and Lieberman became a citizen of the United States of America.

Although he had seven years in which to act on his Petition for Naturalization, it was no accident that Lieberman chose 1922, as the year to instigate the final proceedings. Beginning in 1920, the United States was experiencing an unprecedented wave of anti-Semitic feeling. The unrest in Russia and the fear of encroaching communism became a concern of many

Americans. These fears became associated with the large immigrant population pouring steadily into the cities. Italian immigrants became the target of suspicions of radical activity, but the Jewish population, many of whom came from the Soviet Union itself, were especially suspected of engaging in subversive activities. Sentiments that promulgated the idea that the Jewish "race" operated above the laws which bound everybody else and that, in fact, it had a controlling hand in most world-wide governments, were publicly expressed by such prominent figures as Henry Ford.[31] As record-breaking numbers of Jewish immigrants continued to arrive at Ellis Island, a two-year ban on all immigration was proposed by Representative Albert Johnson of Washington. The ban was reduced to one year, and passed in the House on December 13, 1920. After a series of hearings, the Senate Committee realized there was not going to be a sudden and overwhelming influx of immigrants in the near future. It was concluded, however, that a quota should be imposed on immigration from certain areas of the world population, namely Italy and Eastern Europe. The new bill stated "That the number of aliens of any nationality who may be admitted under the immigration laws of the United States in any fiscal year shall be limited to 3 per centum of the number of foreign-born persons of such nationality resident in the United States as determined by the United States census of 1910."[32] By June 1922, the bill had received Presidential approval and was put into effect.

In 1922, Lieberman sold his store to the Essex Candy Company and retired. In August, of that year, he returned alone to his birthplace of Gniewoszów in an attempt to convince his family to come to America with him.

In the intervening years since he had left Poland, Lieberman had been sending money and clothing to Gniewoszów on a regular basis, benefiting not only his own family but also the entire village. In a posthumous tribute to Lieberman, his nephew, Rabbi Marc Liebhaber, wrote, "The ritual bath, the synagogue, the Hasidic shtibl (prayer and study house) especially built for grandfather, poor brides, widows and just plain needy were beneficiaries of Hertzke Aaron's generosity."[33] As a result, he was regarded as something of a hero in the Jewish community. When he returned to Poland with his clean-shaven face, his peyes (sidelocks) cut off, his head uncovered, and wearing an American suit, he presented a shocking sight to his family (fig. 25). Gniewoszów had not changed, but Lieberman had. His parents were so overwhelmed by his appearance that they treated him like visiting royalty, giving up their own bed so he would have a soft place to sleep.

Lieberman was unsuccessful in his attempt to bring

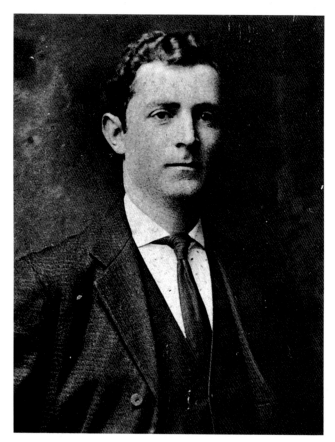

25. Harry Lieberman, photographer unknown, New York, c.1920. (Collection of the artist's family) This photograph of Lieberman shows how he must have looked when he returned to Gniewoszów in 1922. Lieberman rejected the Hasidic garb and shaved his beard shortly after coming to America.

his family out of Poland. The change in his appearance and his lifestyle made the dangers of America all the more tangible to his parents, who had also lost their oldest son to the American dream, although, unlike Harry Lieberman, he had continued leading a religious life. To the pious Hasidic couple, Lieberman must have represented a mixed blessing—their saviour in times of need and yet their failure to instill solid Jewish traditions. They refused to leave, and when Poland was invaded at the start of World War II, both of Lieberman's elderly parents died in questionable "incidents" related to Nazi activity (fig. 20). His sisters and other family members later died in concentration camps. Two of his brothers and several relatives, however, survived the war, one by hiding in a hayrick for many months.

His inability to save the lives of his parents haunted Lieberman's dreams for the remainder of his life. His pain at the loss of his parents, his sisters, his children, and other members of his family and village lies behind the images of the shtetl and the Jewish traditions so lovingly evoked in his paintings.

A few years after his return to America, Lieberman bought his business back from the Essex Candy Company and continued working until 1950, when he decided it was time to retire again, this time permanently. The store was bought by another candy concern, which still operates down the block from 109 Ludlow Street.

After their retirement, Lieberman and his wife moved into a large home in Great Neck, Long Island, where they lived with one married daughter and their grandchildren. For six years Lieberman stayed home using his retirement as an opportunity to educate himself in the secular material he had not had access to in Poland and no time for during his career. He read novels, philosophy, Yiddish literature and any other reading matter he could find, but Lieberman considered these the "worst years" of his life, and his family remembers this as a period of increasing withdrawal and boredom.

In 1956, Lieberman made his first trip to Israel, a trip that was pivotal to his life in many ways. One morning, he left his wife sleeping in the hotel and visited King David's Memorial. At random he opened the Book of Psalms to Psalm 130, "From the depth I called you, Oh Lord." Lieberman decided at that moment to return to the synagogue. "Nobody can run away from himself. You are born a Jew, you are a Jew, and you have to work with that. Otherwise, you are not for yourself."[34] Lieberman learned that the "freethinker" has no "Father in heaven to give him relief or to be on his side."[35]

On his return to America, he spoke with the rabbi of the local synagogue and discussed his wish to return to regular worship. The rabbi suggested Lieberman was coming back to shul because he was old, but Lieberman denied this saying, "My people sit next to the Holy Throne. I am not afraid of dying, I am well protected."[36]

Lieberman's experience at the King David Memorial was one of revelation and spiritual reawakening. Perhaps not coincidentally, this was also the year he began to paint.

Lieberman had been spending time in the local Golden Age Club under the auspices of the Senior Citizen Center of Great Neck. One day, Lieberman's usual chess partner falled to show up at the Center. He was sitting around aimlessly, when one of the volunteers, Jeanne Barron, invited him to join the painting class she supervised on a regular basis. Lieberman was resistent to the idea ("I never held a brush in my hand. How do you expect me to go?") but was finally persuaded. The results were so promising and Jeanne Barron's response

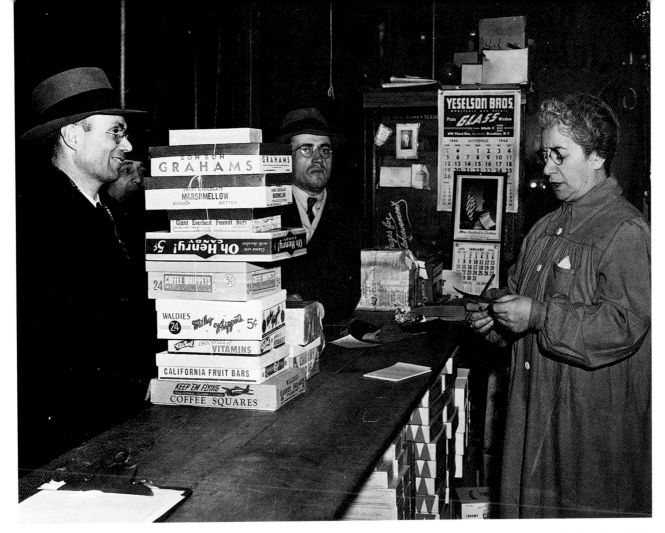

26. Sophie Lieberman in Lieberman's Confectionary Store, photographer unknown, New York, c.1944. (Collection of the artist's family) This photograph shows the interior of Lieberman's Confectionary, which Lieberman and his wife operated from 1910/1911 until 1950. The wholesale store sold name-brand candies as well as dried fruits. The name of the store is partially visible through the glass window.

so encouraging that Lieberman experienced an exhilaration he had not felt since his retirement. He said later "Encouragement means more than money. With this encouragement, she (the teacher) made me again into a man. If you have activity that is what brings you back to life."[37]

Mrs. Barron's policy in working with the senior citizens was to offer little guidance in subject matter or technique, although she set up still-life arrangements for those who needed a direction. Instead, she believed in reacting positively to their efforts without trying to restructure them. After two years with Mrs. Barron, Lieberman enrolled in a painting class offered by the Adult Program of the Great Neck, Long Island, Public Schools. The class was taught by the well-known artist Larry Rivers. After several weeks of working diligently in the class and watching Rivers critique the other students' paintings, Lieberman asked, "You think I have

the measles? How come you go to everyone here saying, 'Do this, do that,' But you never come near me once?" Lieberman recalls Rivers' response, "Mr. Lieberman, the pictures I paint you couldn't paint. But the pictures you paint I couldn't paint. So how could I correct you?"[38] Lieberman never took another art class (fig. 29).

Six years after retiring, Lieberman had embarked upon his third successful career. For the next twenty-seven years he produced a prodigious body of work, sitting at the easel for hours at a stretch. When he was not painting, he was thinking of stories for future paintings, which he carefully wrote in Yiddish and Hebrew on index cards. Painting, and the attention he received because of his art, provided a new incentive for living. "When I go to bed in the nighttime I feel I am going to bed to rest to work tomorrow; and when I get up, I have it in my mind the painting or the sculpture I'll be doing. I know I am not the greatest painter in the

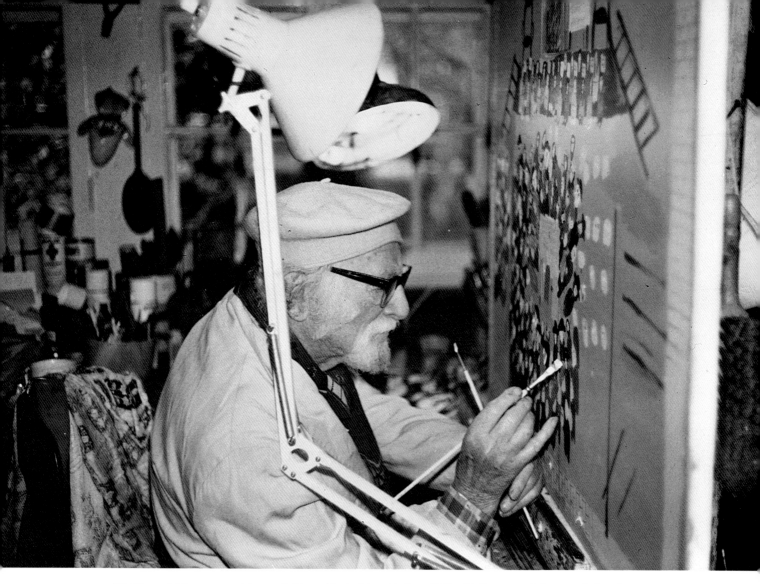

27. Harry Lieberman at his easel, Great Neck, New York, c.1980. (Collection of the artist's family) Harry Lieberman used the enclosed sunroom of his Great Neck home as his painting studio. His paintings still line the walls of the studio and hang throughout the house.

world, I know not all my paintings are the best I made. Some are good, some not so good. But I have respect for my work from the other people."[39]

Lieberman threw himself wholeheartedly into his role as artist. By the late 1960s he began sporting a beard and a long ponytail, and wore an artist's smock and a beret (fig. 27). As he said, "When I was a child in a Hasidic family, I dressed like a pious child, and when I was a merchant I dressed like a merchant, and now I dress the way you see me, but me, I don't change."[40] He especially loved to work outdoors in his garden, surrounded by neighborhood children whose company he encouraged.

Lieberman continued to paint flowers and still lifes throughout his career (fig. 51). It was his paintings of Jewish themes, though, that galvanized public attention and spurred *Pageant* magazine to name him in 1962, "One of the ten people to watch."

After his wife's death in 1967, Lieberman began spending more time each winter with his daughter Rose in California. There, his paintings interested not only the Jewish community but also groups involved with the peace movement and issues of religious tolerance. It was in this regard that he became well acquainted with Sister Mary Corita, whose serigraphs promoting peace were widely known. In 1967, he became associated with the Botolph Gallery in Boston, and its founder, Celia Hubbard. In 1968, Ms. Hubbard wrote, "...Harry Lieberman and his work can bring us all back to a spiritual quality in our lives..."[41] In 1971,

Lieberman was invited to participate in Saint Andrew's Priory's annual exhibition of religious art. He remained at the Priory in Valyermo, California, for two weeks, March 28 to April 8, and worked with Father Yang in the ceramic shop, where he created a figure of the prophet Isaiah.

In 1976, Lieberman became one hundred years old, according to his own calculations, and there was a flurry of celebrations, exhibitions and publications. His paintings were used to illustrate the 1976 Jewish Folk Art Calendar and he signed a contract to produce calendars for the next several years. In 1979, he was honored by the Los Angeles Board of Education as the "Artist in Residence" at Fairfax High School. He continued devoting time to the art program until 1981, to painting, and to discussing his life and answering questions posed by the students. From 1979 until 1981, Lieberman participated in walkathons for Soviet Jewry, covering distances of at least one mile.

Lieberman's age has been a seemingly endless source of fascination for the public. According to Lieberman's own memories, he was born in 1876, but disparate dates appear on various documents and in the family's oral traditions.

At the time of Lieberman's birth, records of the Jewish community might be maintained in a community's religious records, some of which have survived the war. Volumes such as mohel books (records of ritual circumcision), and pinkasim (congregational minutes) have beome invaluable sources of genealogical information for families trying to trace their origins. Many of these records featured decorated headings or pages, becoming part of the visual aesthetic of the shtetl.

Civil registration records of births, deaths, and marriages were also kept. Because Poland was annexed by Russia during the period in which Lieberman was born, many of these records are handwritten in Cyrillic script. Some of these civil registration records still exist for many of the small East European communities and, in fact, such records are extant for Gniewoszów through 1877, although Lieberman's name does not appear. The title page for each year was frequently cut in a foliate form that recalls the painted and shaped frames Lieberman frequently imposed on his paintings (fig. 39).

Lieberman's birthdate of 1876 is based on his own memories and the memories of other family members. This, however, does not agree with the 1881 date that appears on the passenger lists, the Certificate of Arrival, or the naturalization papers. Lieberman celebrated his birthday on November 15th, which also differs from immigration papers that document his birthday as either September 15th or September 24th.

An inquiry to the National Polish Archives brought a response that five documents still existed in Poland bearing the Liebhaber family name. Five of the documents have since proved to be birth records for Lieberman's father, three of his sisters, and for Lieberman, himself.

The entry was discovered in the Radom records for the town of Gniewoszów. It is dated October 30, 1880 and states that a male child was born to Aaron Liebhaber and his wife, Esther Liebhaber. The child was born on October 22, 1880 and was given the name Naftuli on this, the day of his circumcision.

In light of this discovery Lieberman's age at different milestones of his life must be recalculated. He was twenty-five when he came to America, seventy when he retired, and seventy-six years old when he started to paint. He continued painting until 1983, when he died shortly before the age of one hundred and three.

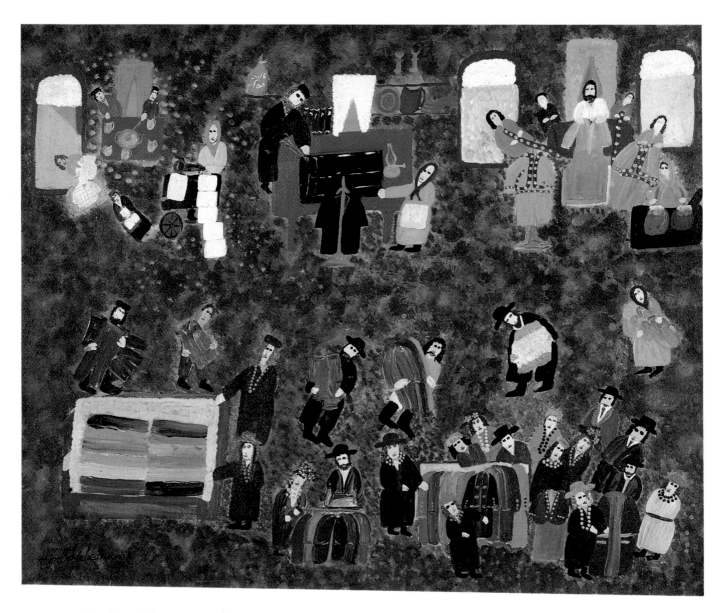

28. *The Clothing Cutter/The Sweat Shop*, c.1967, oil on canvas, 24″ x 30″. (Collection of Mr. and Mrs. Lawrence Schoenbach) Many Jewish immigrants who came to America found their first job working in one of the many sweat shops on the Lower East Side. Lieberman worked as a cutter from 1906 until 1910, when he started his wholesale candy store. This painting shows the many aspects of the business from cutting the cloth to the purchase of finished goods. The family in the upper left corner labors on piecework goods that they have taken home to supplement their meager earnings.

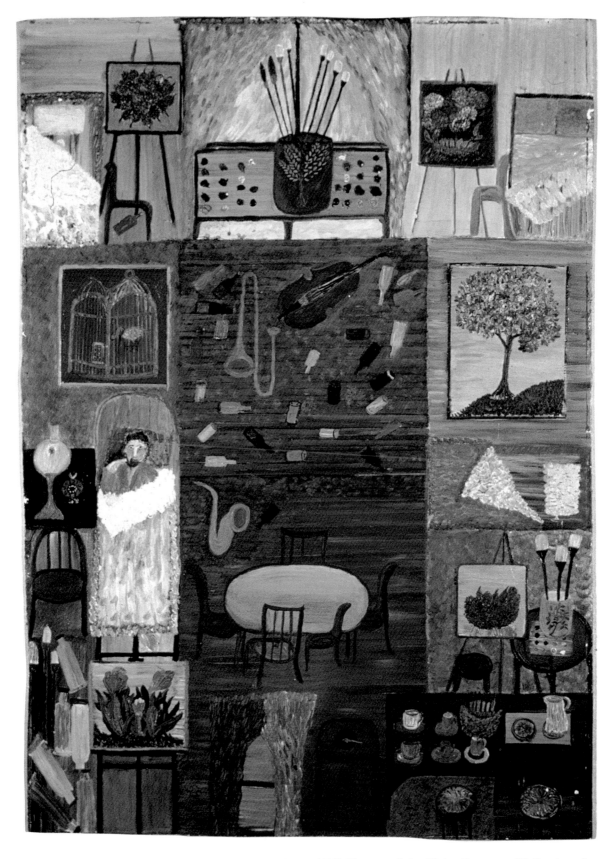

29. *The Morning After*, c.1963, oil on masonite, 21¼″ x 29½″. Photograph by Elaine Guttman. (Collection of Elinor Blake and David Blake) Lieberman's only professional painting class was with the well-known artist Larry Rivers, who bought a few of Lieberman's paintings. Lieberman visited the artist in his studio the morning after Rivers had thrown a party. Lieberman, expecting the artist's studio to be a scene of decadence, made his daughter wait downstairs in the car while he visited. He shows Rivers still in bed, with empty wine bottles dotting the floor of the studio. The studio is filled with artworks—all of them painted by Lieberman!

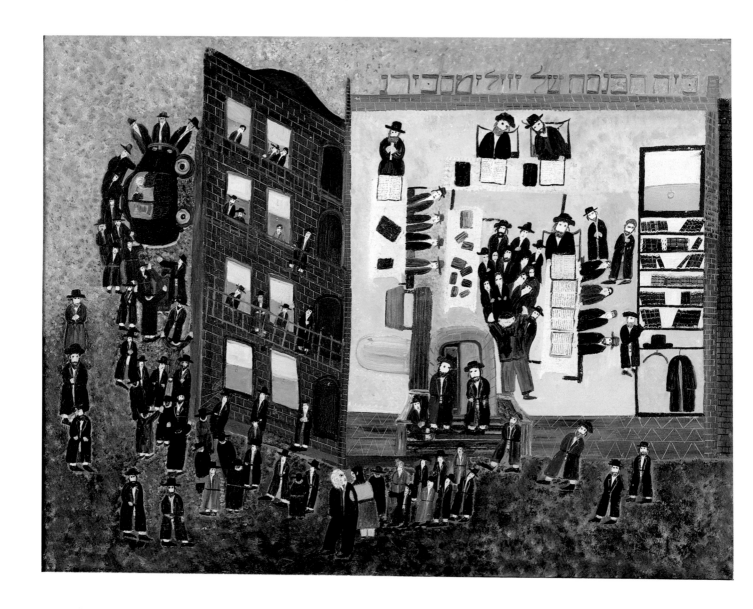

30. *The Most Orthodox Rabbi*, c.1968, oil on canvas, 30″ x 40″. (Private collection) One Saturday, I went with my granddaughter to a Hasidic synagogue in Brooklyn to hear the rabbi's definition of the Talmud. When I was coming up the stairs, three men stopped me. They thought I was a gentile because I had no beard, no prayer shawl, and no yarmulke on my head. I took out my yarmulke to show I am a Jew. I had a watch. A true Jew, they said, don't wear a watch on Shabbos, the Sabbath. Even after I showed I knew the Talmud they made me leave. It was raining, they understood I came in a car, and some students followed us and yelled I was abusing the holiness of the Shabbos by riding. A real Jew walks. They kicked and pushed the car. In one way I don't blame them. The laws says every Jew is responsible for every other Jew to keep him in the true religion. Maybe it wasn't the right way, but they wanted to make me a "good" Jew again. ☆ This story dispels any notions that Lieberman was a ritually observant man. He deliberately flouted the most basic proscriptions of the Sabbath, the day of rest, by traveling in a car and wearing a watch. Furthermore, he did this in one of the most Orthodox Jewish neighborhoods of New York City, the Hasidic community of Williamsburg. The Hasidic synagogue is housed in an ordinary tenement building, as shown by the exterior view. The facade appears as though it were hinged to the building, and when opened reveals the interior of the study hall, the rabbi's office, and the congregational area. The windows and stoops are lined with Hasids who are denying Lieberman and his granddaughter access to the sanctuary. His granddaughter walks away with her head slightly inclined, but Lieberman walks in a posture of defiance, glancing back with a mixed expression of disgust and pity. A moment later, they are surrounded in their car as they drive away.

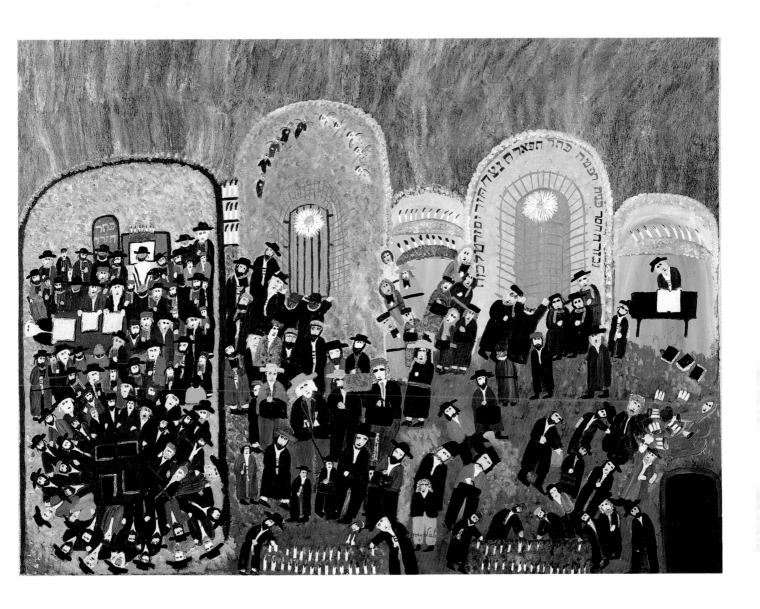

31. *Pray and Sing and Dance to the Psalms of King David,* c.1972, acrylic on canvas, 30″ x 40″. (Private collection) Machpelah is the site purchased by Abraham to bury his wife, Sarah. According to tradition, Abraham, Sarah, Isaac, Rebekah, Jacob, and Leah are all buried there. Today, the site of the cave is identified with the city of Hebron. For seven hundred years, Jews were not allowed to enter the tombs. Now, each year thousands of visitors to Israel visit the site and regular services are held there. The Tomb of Abraham and Sarah, in Jewish folklore, is considered "the Source," or God's presence. Lieberman has written the names of the ten sefirot over the Tomb: (Keter (crown); Hokhmah (wisdom); Binah (understanding); Hesed (lovingkindness); Gevurah (power); Tiferet (beauty); Netzah (victory); Hod (majesty); Yesod (foundation); Malkhut (sovereignty). Lieberman has painted Machpelah as a series of arches, perhaps as a visual reference to the vaulted Byzantine church that was built at the southeastern end and later converted into a mosque. A religious service is being held in the left arch while other visitors light candles. Lieberman, his daughter, and his granddaughter are all included in the scene. The Orthodox Jews at the bottom lean over the candles in a pose that echoes the procession of arches at the back. The arches appear to be doorways into a spiritual dimension, rather than physical structures—a symbolic scheme established in medieval illuminated manuscripts. The "ether" outside the arches creates a feeling of flux, of shifting forces. The title of this painting refers to Lieberman's revelatory experience at the Tomb of David, at Mount Zion.

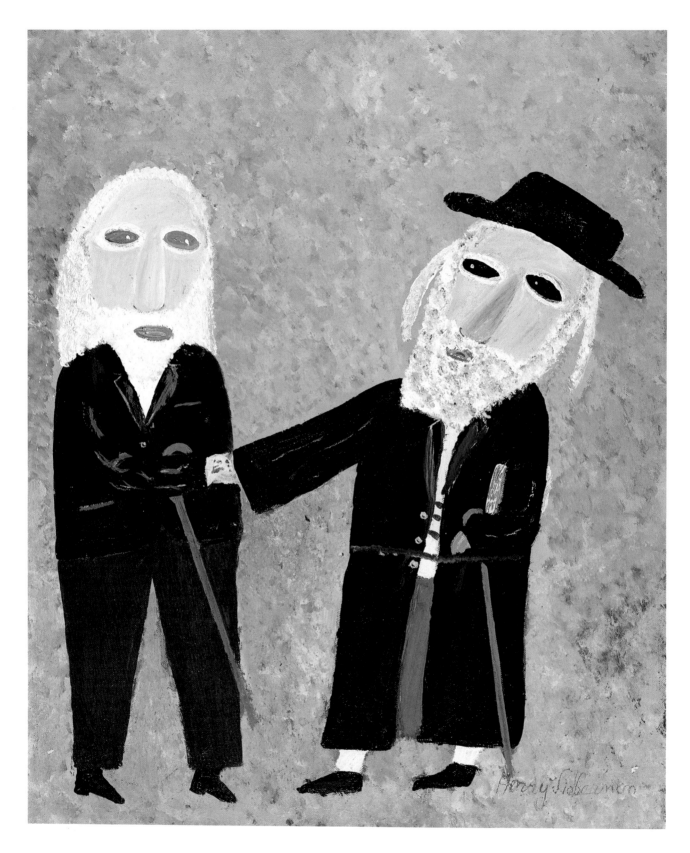

32. *The Artist and an Old Jew in Jerusalem*, c.1972, acrylic on canvas, 24″ x 16″. (Private collection) I met this man and he was bent over because as a Jew, Isaac said to Jacob that, "The voice is yours, but the strength of hands belongs to Esau." For me, I think that since we have the State of Israel, it's time we felt as Jews that we have not only voices but great strength as well. ☆ In this painting Lieberman equates the blessing of Jacob in Esau's stead with the State of Israel. He felt that the ethical basis of Judiasm contained in the oral traditions could now be joined with the strength and confidence that comes with the establishment of a homeland; Jacob and Esau combined as a single entity.

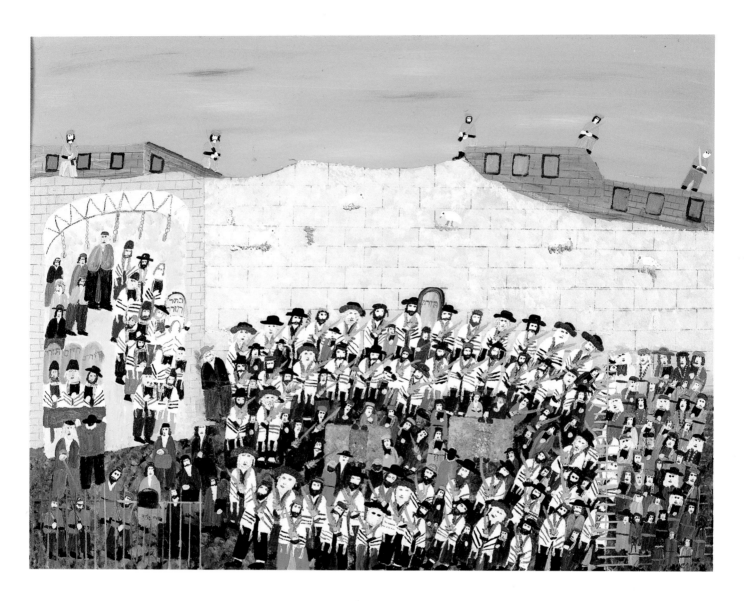

33. *The Wailing Wall*, c.1972, acrylic on canvas, 30″ x 40″. (Private collection) Lieberman has painted the Wailing Wall, or Western Wall of the Temple that was destroyed in 70 CE The people visiting the wall are celebrating the holiday of Sukkot, or Feast of the Tabernacles. This holiday originally held agricultural significance and four species of plants must be represented: the lulav, or palm frond, which is bound on one side with three sprigs of myrtle and by two willow branches on the other, held with palm leaves. The spine is held in the right hand and an etrog, or citron, is held in the left. Together, they are waved three times in the four directions, as well as up and down while the prayer, the "Hallel," is recited. Lieberman has painted the celebrants standing around two Torah scrolls. To the left, he shows a view of the cavern beneath "Wilson's Arch" that is not actually visible from outside the wall. The interior of the cavern is divided into three holy arks that Lieberman depicts as one group with the words "Etz Chaim Torah," or "Torah is the way of life." He stands in front of the arch holding his cane and wearing a yarmulke, but no tallis (prayer shawl).

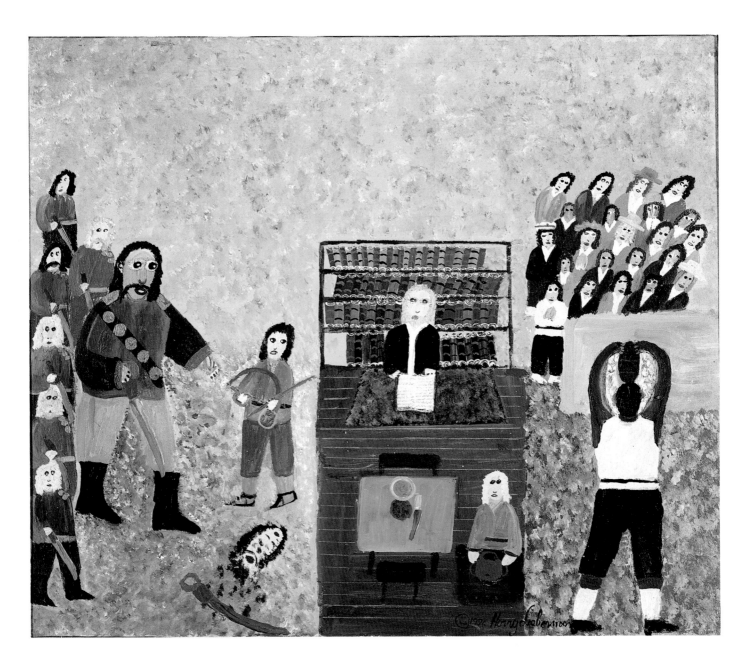

34. *The Dollar Value of Education*, 1976, acrylic on canvas, 20″ x 24″. (Private collection) A few years ago, the artist read in the newspaper that a basketball player had agreed to play professionally for $250,000 a year. How could this be? A professor, the most important person in the world, makes only a small amount of the basketball player's salary and yet he is significantly more worthy of the salary. A professor teaches others the value of knowledge so that the things we learn may continue into future generations. It is a very mixed-up world where the value of knowledge is held in such low esteem. ☆ To Lieberman, who had received no secular education, it was inconceivable that a sports figure was held in higher esteem than an educator. He shows the teacher as a rabbi in his study with all his books of learning behind him and a book open on the table before him. On either side of the rabbi, Lieberman juxtaposes the basketball player with the story of David and Goliath. David uses his intelligence to defeat the greater strength of the Philistine—the triumph of intellect over physical strength.

CHAPTER III

HASIDISM

The Jewish community of Gniewoszów practiced Hasidism, a form of Judaism founded in the late-eighteenth century by Rabbi Israel ben Eliezer. The term "Hasid" has been in use since biblical times to denote one of pure and religious spirit, but the term also came to mean the practice of a form of Judaism based on the precept of direct communication with God, fervent belief in and longing for the coming of the Messiah, and of the accessibility of spirituality to the masses, not only the scholarly adherents of rabbinic Judaism. Hasidism has been called one of the greatest revivalist movements of Jewish history, rejecting what was claimed to be the narrow intellectualism of Talmudic Judaism that many felt "…estranged the Jewish masses from their heritage."[42] Ordinary Jews could experience a transcendant ecstasy through "deeds of loving kindness carried out with joyful intensity."[43] Hasidism is closely allied with the fundamental teachings of the Kabbalah, the system of Jewish esoteric thought and mysticism. Although kabbalic mysticism did not emerge until the twelfth century, mystical exploration can be traced back to the origins of Judaism. The great scholars of the post-biblical periods examined every biblical word for the "inner" meaning, the "sitrei Torah," or "Secrets of the Torah." They felt that beyond the "garment" of the word lay the true meaning. A body of folklore grew around biblical events and the prophets, especially the chapter of Creation and the description of the Divine Chariot contained in Ezekiel's dream. An elaborate system of angelology and demonology arose, and the power of the Ineffable Name of God—Shem Hameforash—was felt to be too dangerous for all but the most learned—an idea maintained by rabbinic Judaism as well. Mystical theories generated a large body of literature, including the important "hekhalot" (palaces) literature that describes in detail the halls and palaces of the household of the upper world: the ministering angels, the angels of destruction, the roving spirits, the King of the Demons, the Demon of the Night, and the guardian angel of souls.

The concept of emanations known as "sefirot" is central to Hasidism. God is conceived of as the "Ein-Sof," the "Infinite and Unknowable." The Ein-Sof is linked to the visible world through the emanations of ten sefirot, contained within and emerging from the Godhead. The world was formed by these emanations, but when Adam was expelled from Eden, the "Shekinah," or "Divine Presence" (often considered the feminine aspect of God) was similarly expelled from the Ein-Sof. This dichotomy allowed evil into the world and harmony will only be restored when the Shekinah is reunited with the Ein-Sof. The great mystic, Isaac Luria (1534–1572) further developed this concept with the theory of "tzimtzum," or "contraction and emanation." Since God is everywhere, He had to create a space in which the world could be formed. In order to do so, he withdrew into Himself, leaving a vacuum that contained a thin residue of His light. The ten sefirot allowed the Divine light to reenter the vacuum, but during this process the lights of the Ein-Sof were shattered in a catastrophe known as the "breaking of vessels" or the "Death of Kings." Sparks of this Holy Light were scattered and trapped in "isolated shells." It then became the duty of mankind to release this Divine Light from the vessels, or husks, and to reawaken the "sparks" through prayer and holiness. Only when all the sparks have been released can the Messiah appear.[44]

Hasidism was developed through the vision and personality of Israel ben Eliezer, more commonly referred to as the "Baal Shem Tov," or "Besht" (fig. 35).

Baalei Shem, "Masters of the Name," were itinerant healers and teachers who worked "miracles" through the use of the Divine Name. The Baal Shem Tov first achieved renown as a miracle worker, but soon revealed himself as the proponent of a new emphasis in Judaism.

The eighteenth-century Polish Jewry that received his message was torn by pogroms, arduous taxes forced conscription, and poverty. The heady ideologies of mystics such as Isaac Luria and the devastation of self-proclaimed messiahs, Sabbatai Zevi (1626–1676) in particular (fig. 59), were at strange odds with the Talmudic legalism and vast intellectualism that had characterized the golden age of Polish Jewry.

The Baal Shem Tov introduced a campaign that restored morale, faith, and joy in a world that had been joyless for some time. His aim was to produce a group of men devoted to a life of purity and spirituality, for whom this world was merely a stepping-stone to the next life. The highest aspiration was to receive possession by the holy spirit (Ruach ha-Kodesh), a level of ecstasy achieved in ancient times by the prophets and the sages. This aim also served to insure a life on earth devoted to holiness, selflessness, and brotherhood. Every trial and tribulation endured by the Jewish people was interpreted as a test of this faith, an interpretation that gave meaning to the hardships endured by the Jewish masses.

The Baal Shem Tov's disciples came to be called "Tzaddikim" or "Righteous Ones" and their congregants as "Hasidim." The teachings evolved as an oral tradition, but have come down to us through the written records kept by disciples in the name of the rabbi who uttered them.

In essence, Hasidism became a kind of folk religion for the oppressed masses of East European Jewry whose spirits, trampled by the unceasing pogroms and untouched by the lofty religious discussions of their rabbis, needed to believe in a joyous affirmation of life on earth and reward in the world to come. This expression often took the form of dancing, song, and ecstatic prayer. The reaction against Hasidism by traditionalists was based, not on a difference of belief, but on a difference of expression. The Hasidim adopted the liturgy of Isaac Luria, which differed from the German-Polish ritual. This meant that they had to establish their own houses of worship. The Hasidim felt that sincerity and fervor of prayer (devekkut) took precedence over a slavish devotion to worship ruled by a timetable. To the opponents of Hasidism, mitnagdim, this presented a serious threat and undermined the long-established traditions of Orthodox Jewry.

Hasidic teachings were disseminated in stories and parables that could be understood by the many, as opposed to the intellectual pilpul (dialectics) that were understood by the educated few. The Hasidic "sayings" became one of the means by which the movement was spread to ever-widening circles of influence among the Polish Jewry. With the mantle of leadership passed from "Master" to "Disciple," the Hasidim established "courts" that reflected the temperament and emphases of their particular spiritual leader.

One of the most frequently occurring themes in Harry Lieberman's works are paintings based on the ethical maxims contained in the Mishnah. The Mishnah is the earliest codification of the laws of the Torah and the oral laws, compiled, it is believed, by Rabbi Judah the Patriarch. The Mishnah contains the aggregation of four centuries of religious activity and thought from the early-second century BCE until the end of the second century CE.

The system of homiletical teachings developed by the Hasidic Masters lent itself more readily to certain tractates of the Mishnah than others. One of the favorite sources for Hasidic wisdom is the ninth tractate of the Order Nezikin, the "Pirkei Avot," or "Sayings of the Fathers." These sayings are not based on specific commandments from the Torah, but reflect the ethical precepts of Judaism in the words of the sages who lived before and during the Talmudic period, in a brief six chapters. The moral imperatives contained in the Pirkei Avot are sometimes called a "derech chaim," or "way of life." Midrashic interpretation considers the ethical directives of the Pirkei Avot a "guardian of the way" to the "Tree of Life"—the Torah. The Hasidic leaders used these maxims as springboards for their own messages. The strength of these messages is evident in the fact that Lieberman has illustrated more passages from this short work than any of the other voluminous Jewish commentaries.

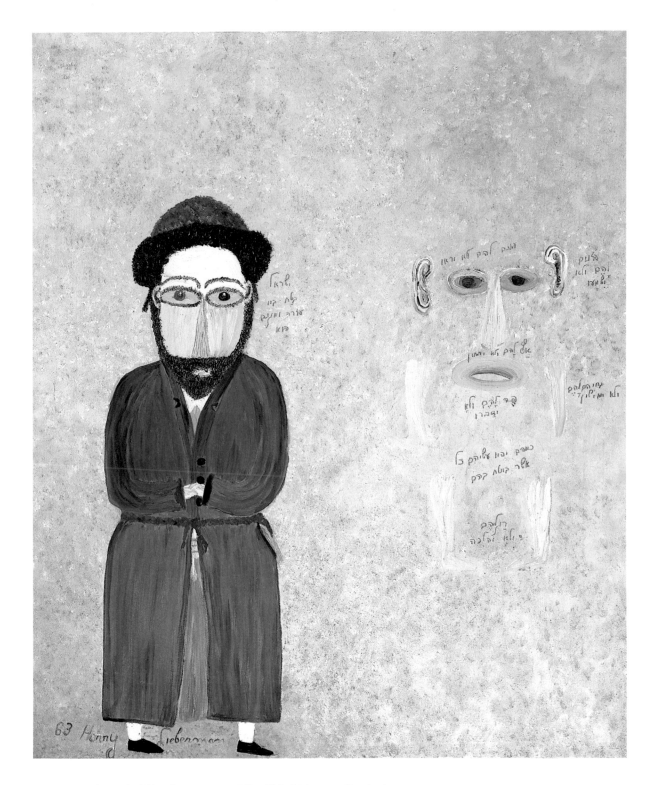

35. *Psalm 115*, 1963, oil on canvas, 24″ x 20″. (Private collection)

> 2 Wherefore should the nation say where now is their God?
> 7 They have hands but they touch not; they have feet but they
> walk not; nor do they give any utterance by their throat.

Lieberman juxtaposes the worship of lifeless idols with the figure of Israel ben Eliezer, the founder of Hasidism whose joy in life, in worship and in God infused generations of Jews with a new fervor. The question in line 2 concludes with the words, "When our God is in heaven and all that He wills He accomplishes. Their idols are silver and gold, the work of men's hands." The Baal Shem Tov is depicted as a man in Hasidic garb. He wears a shtreimel (fur-brimmed hat), tzitzes, or ritual fringes, and peyes, the uncut sidelocks that distinguish Hasids. The idol, on the other hand, is merely a collection of unconnected body parts with the words of the text identifying them. Lieberman has also used this theme in his clay sculptures, forming the limbs from clay much as they appear here.

36. *The Blessing of the Moon*, c. 1977, acrylic on paper, 20″ x 16″. (Private collection) The Jewish people got the custom to bless the new moon just when it is coming up. Now, Reb Chaim used to bless the moon by doing a special deed. Once he wasn't feeling so well, and he sent his beadle to see if the moon is out yet. The beadle reported, "The moon isn't there at all and it's cloudy." "Give me my lilke, my long pipe," the rabbi said. "I will blow smoke and chase away the clouds so we can make the prayers." He blew the smoke from the lilke out the window. The clouds went away, and they made the blessing to the moon. Where did he come to the idea that the smoke from the lilke will move away the clouds? When the Holy Temple existed, the Bible said you should burn incense so the smoke should carry the prayers to heaven. I myself think it made a good smell, and not much more. ☆ By counting time against the regular phases of the moon, it became possible for the early Jews to celebrate their holidays and religious observances at the proper times. The new moon occurs after sundown on the first day of each lunar month. The Jewish year is divided into twelve months of alternating twenty-nine and thirty-day intervals, except in leap years when there are thirteen months. On the shorter month, the new moon is celebrated the next day; on the longer month it is celebrated both the last day of the month and the first day of the next. In ancient times, the new moon was declared by eyewitness accounts that were carefully substantiated in several locations and reported to the main judicial body in Jerusalem. Lieberman frequently relates an appealing story or legend only to append his own skeptical remarks. But his careful disparagement of this story is belied by the ethereal quality of the painting. The rabbi sways to one side with his large pipe, and his Hasids sway in the other direction around him. The wisp of smoke trails from the pipe through the study and into the starry night where the crescent of the new moon is revealed. The Hasidic fondness for smoke was notorious, and the Hasidim maintained that smoking a pipe released "holy sparks" that were otherwise inaccessible.

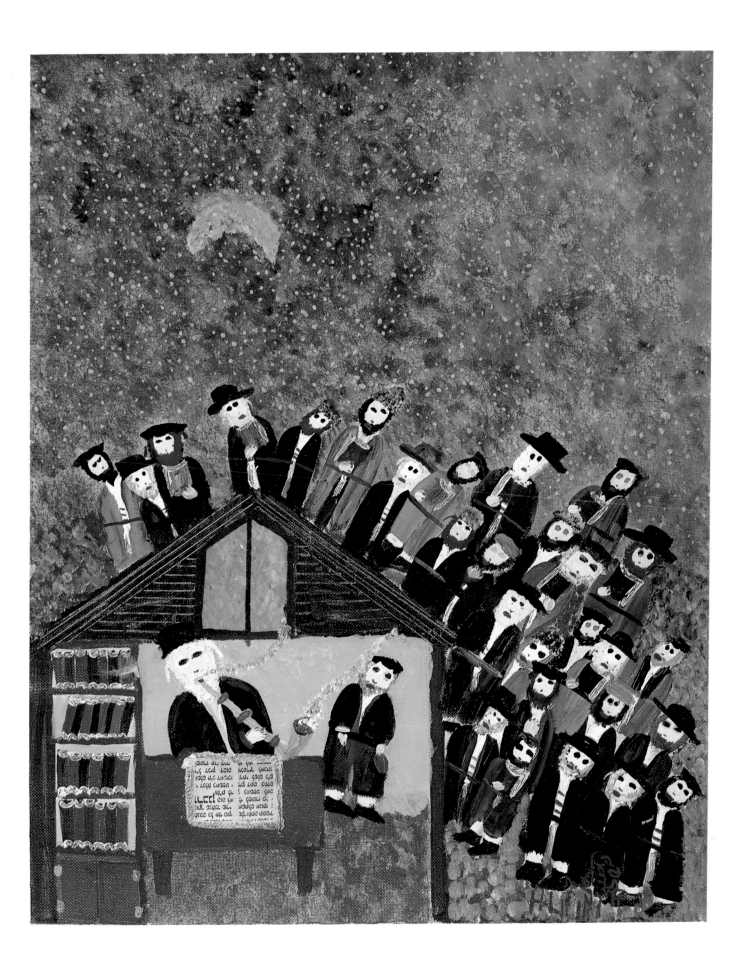

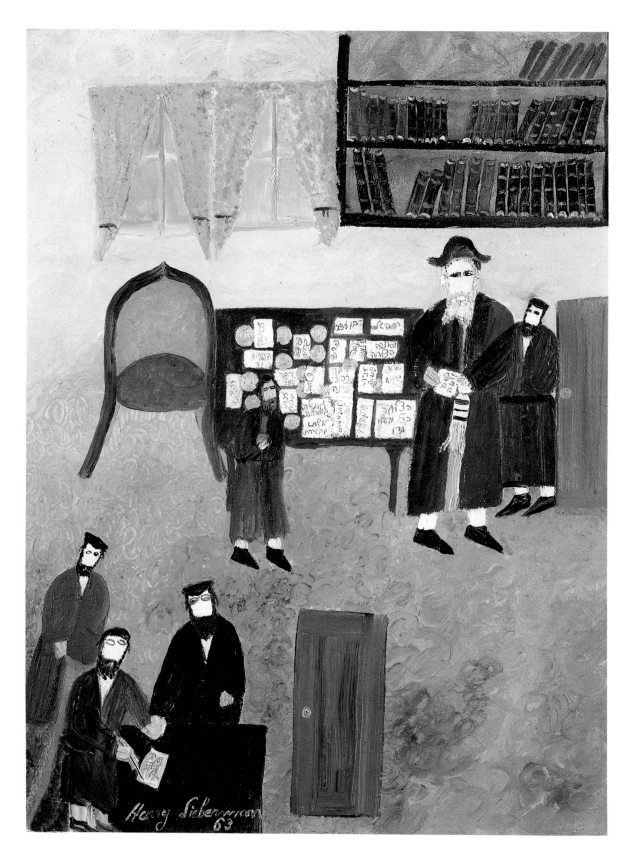

37. *A Note to the Rabbi*, 1968, oil on canvas, 18″ x 16″. (Private collection) I witnessed this myself around sixty-seven years ago. In the Old Country, when a person has some trouble, he goes to the rabbi, and the rabbi's assistant writes down a note of what he wants and gives it to the rabbi with a coin, and the rabbi tells him everything will be all right, because the people believe that the rabbi had connections "Upstairs." ☆ The Hasidim of Eastern Europe regarded their rabbis as spiritual leaders who had the ability to communicate directly with God. In times of financial troubles or in matters of health, the Hasidim might submit petitions to their rabbi in the hopes that he could help through special prayers that would reach "Upstairs."

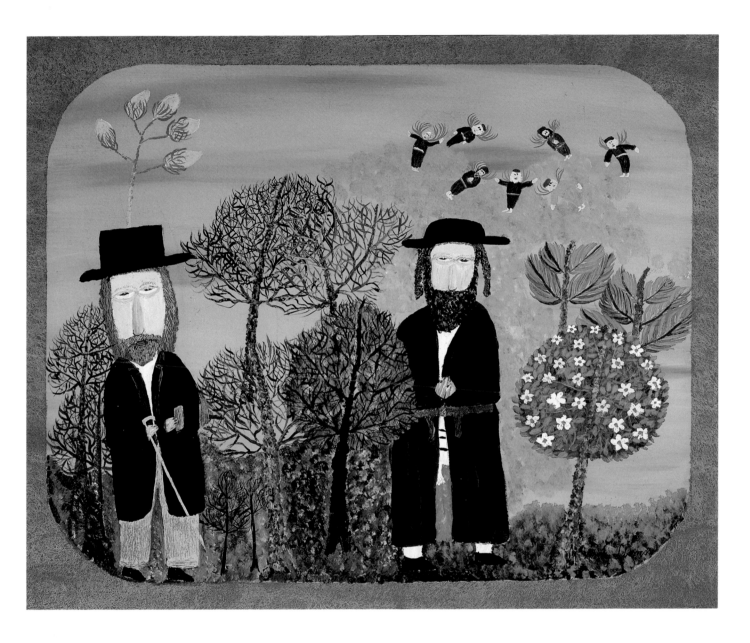

38. *Two Dreamers*, c. 1966, oil on canvas, 24″ x 30″. (Collection of David L. Davies) This painting shows two ideas of what is heaven. One dreamer is Ben Eliezer. He founded the Hasidic idea. The other is a philosopher, not religious. The philosopher doesn't believe there is a heaven up there, so he wants to bring it down to earth where the people are. In plain words, you got to make life so that the paradise is here. Ben Eliezer, he wanted to bring mankind up to heaven and give his people this hope when they were in misery. "Don't worry," he said, "this is only a passing way, only temporary. The main idea is afterward, the hereafter. Up there you will have meat, bread, wine. If you have faith, then everything is right." You got to have both in yourself, philosopher and dreamer. Use your will to improve your life here, and keep up your home. This is how heaven helps you."
☆ This text expresses Lieberman's own philosophy of life as it evolved from his life in Poland through his experiences in America. Lieberman found his "paradise" in the successful life he made for himself and his family, and he felt that the paintings he created were his "hereafter." It is interesting, then, to examine this painting and find that the trees around the philosopher are bare of any leaves and the ground he stands on is dry and lifeless. The flower growing behind him is the only indication of a fruitful life. The Hasid, on the other hand, stands on a field of green, amid a veritable grove of foliage and trees. The ways of ethical behavior to reach identification with the ten sefirot is symbolized by the palm tree that seems to sprout from the flowering tree in the foreground, and seven angels hover over his head in an ethereal cloudburst that surrounds his figure.

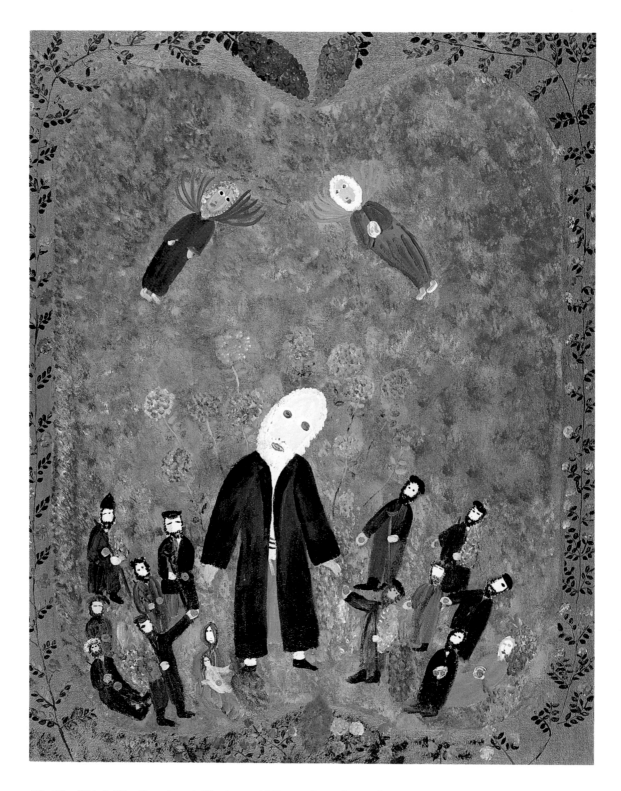

39. *The Third: The Practice of Charity*, c. 1970, acrylic and metallic paint on canvas, 30″ x 24″. (Private collection) Simon the Just was one of the last survivors of the Great Temple. He used to say, "Upon three things the world is based: Upon the Torah, upon the temple service, and upon the practice of charity." ☆ This verse from the Pirkei Avot 1:2 outlines the basic precepts of Judaism. According to some sources, these three principles are symbols of the three patriarchs—Abraham, Isaac, and Jacob. Others say that the world was created for the sake of these three principles and endures because of them. Lieberman has chosen to illustrate the last of the three: the practice of charity. Simon the Just (or Shimon the Righteous) is depicted as a benevolent father reaching out his hands to those in need. His white-haired head signifies his sagacity. The shaped frame around his composition recalls the foliate paper-cut designs that sometimes graced the title pages of congregational minutes and civil registration records in Eastern Europe.

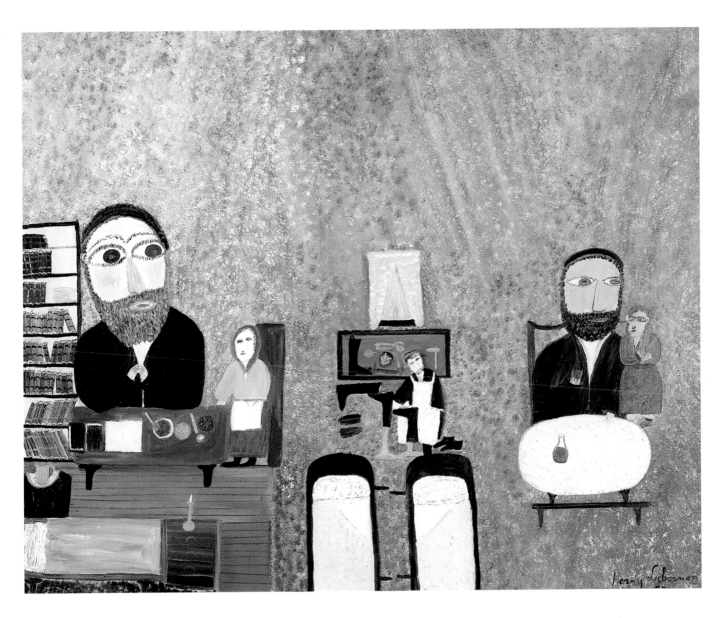

40. *The Strength of Love*, 1967, oil on canvas, 24″ x 30″. (Private collection) The scholar rented a room from a shoemaker and his wife and soon fell in love with the woman. For many months he lived in sin with her during which he cut his beard and had everything he could to look young and handsome. One day he suddenly realized that he had forsaken all his great knowledge by becoming vain and by breaking the Ten Commandments. He had gained nothing at all for this sacrifice. As King David said, "The strength of love will lead a man even unto hell." ☆ This story derives from the Pirkei Avot 1:5, "...Do not engage in too much conversation with women." This has been said even in regard to one's own wife, how much more does it apply to his neighbor's wife. Accordingly, the Sages said: "Whosoever engages in too much conversation with women, brings evil upon himself, neglects the study of the Torah and in the end will inherit Gehennom." In Lieberman's painting the shoemaker is situated at the center of the composition. He works diligently at his cobbler's bench, his small size indicating his lack of awareness of the transgressions taking place around him. The figure of the scholar becomes larger in each of the two surrounding vignettes. On the right, he is shown beguiled by his love for the cobbler's wife, but on the left, his realization of what he has done looms large as he sits among his neglected books of learning.

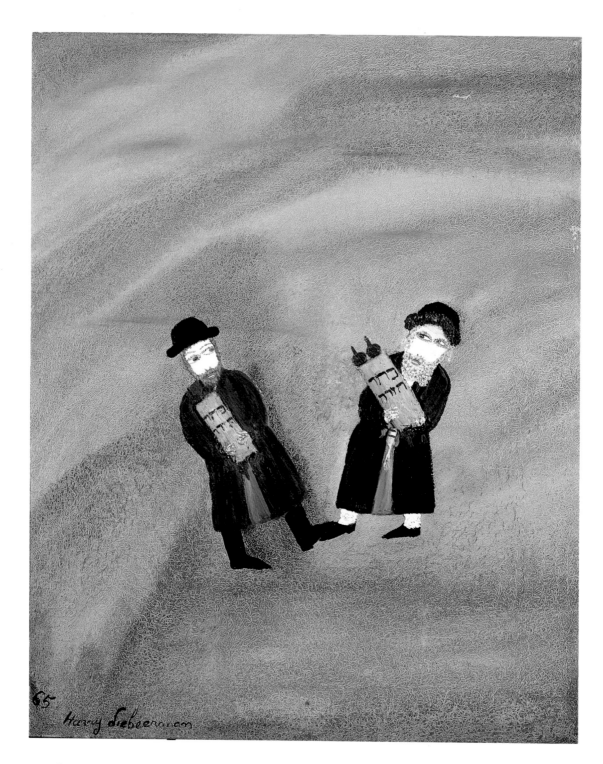

41. *The Wrong Way of Thinking*, 1965, oil on canvas, 20″ x 16″. (Private collection) One year on the holiday of Simhat Torah the rabbi saw someone whom he knew dancing with a Torah. And he said to the man, "We both know that you do not know what the Torah means, so why are you dancing with it?" To which the man replied, "Why shouldn't I dance with it? It made me two hundred dollars." When the rabbi asked him how, he said, "I went to a friend and asked him to lend me two hundred dollars which I promised to return within two months. After two months had passed, he came to me and asked for the money. I told him that I did not even know him and had not borrowed any money from him. When he took me to the rabbi, I swore to this on the Torah. That is how I made two hundred dollars with the Torah. Now you can see the reason for my dancing."
☆ The Pirkei Avot 1:13 says, "…he who puts the Crown (of Torah) to his own use shall perish." Not only has the subject of this painting perverted the holiest book, the Torah, but he is mocking the act of rejoicing and celebration on Simhat Torah, the holiday that marks the reading of the last Torah portion for the year and the beginning of the next year's cycle. This painting features some of the hallmarks of Lieberman's early work: single elements floating in space, built-up areas of heavy paint, and the rainbow-like background of pastel shades.

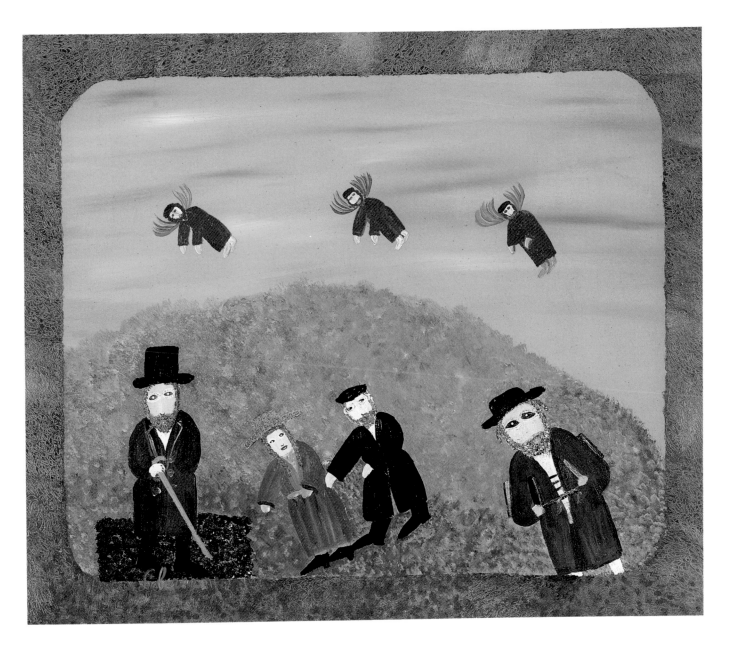

42. *Three Sins*, c.1971, acrylic on canvas, 20″ x 24″. (Private collection) In the Wisdom of the Fathers a wise rabbi once said, "Greed, lust after that which is morally forbidden and high-hatted self-importance carry the seeds of destruction and will bring a man to a grave at an early age." ☆ Lieberman has paraphrased the words of R. Eleazar ha Kappar in the Pirkei Avot 4:21, "Jealousy, lust and ambition put a man out of the world." Lieberman has substituted the phrase "high-hatted self-importance" to indicate a feeling of pompous pride. In the later years of the development of Hasidism, competing sects sometimes used the height of their hats to demonstrate the importance of their own rabbi.

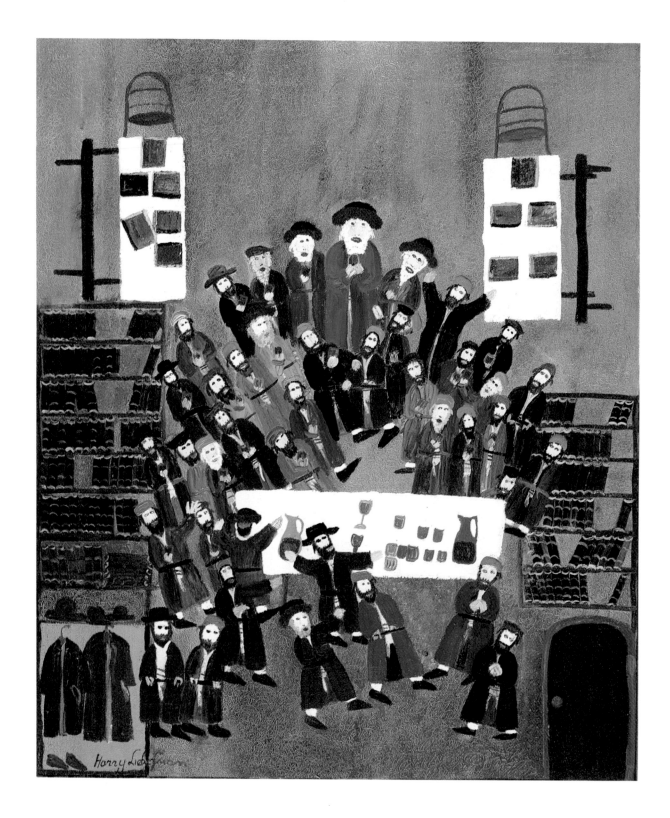

43. *Happy Art Thou*, c.1969, acrylic on canvas, 24″ x 20″. (Private collection) Happy art thou in this world and it shall be well with thee in the world to come. ☆ This saying from the Pirkei Avot derives from Psalm 128:2, "You shall enjoy the fruit of your labors; you shall be happy and you shall prosper." One of the messages of the Pirkei Avot is that the study of Torah cannot be performed properly if a person is worried about providing food and shelter for himself and his family. Meeting his family's basic needs provides the peace of mind needed for devotion to study. This, in turn, brings rewards in the next world. Hasidim are renowned for their joy in worship. Lieberman has painted a scene of Hasidim gathered around their rabbi, the largest figure in the center. The wine flows freely and the Hasidim dance in celebration. The original blue background that Lieberman painted on the canvas is visible in the wardrobe where the rabbi's coats hang. The door in the lower right corner indicates the entrance into this interior.

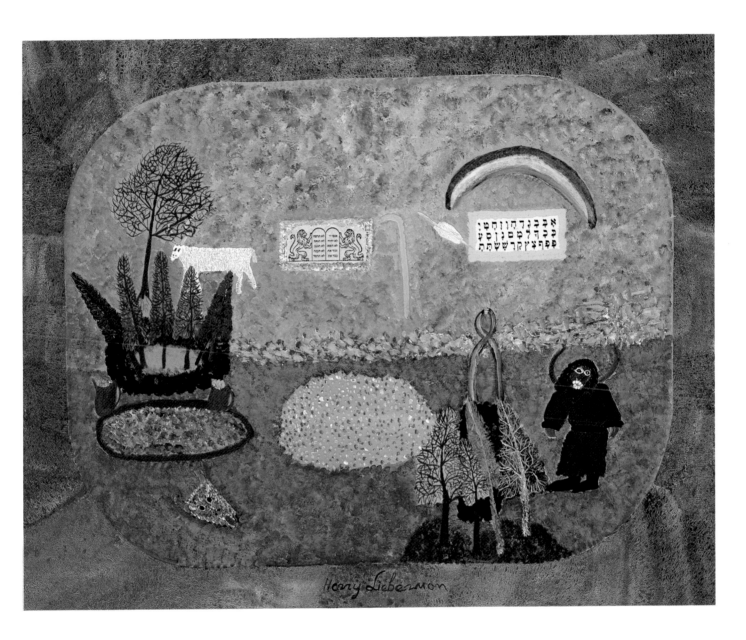

44. *The Ten Items that Were Born on the End of Friday, the Beginning of Sabbath*, c.1974, acrylic and collage on canvas, 24″ x 30″. (Courtesy the Morris Gallery, New York) The mouth of the earth, which opened and swallowed Korach, the mouth of the water which sustained the Hebrews in the desert, the mouth of Balaam's donkey, the rainbow, man, the cane with which Moses laid the ten plagues on Egypt, the asumal—the little bird that cut the stone for the Holy Temple for King Solomon, so that iron would not have to be used, which is used in the making of war, the alphabet, the pen, the tablets on which Moses wrote the commandments. Some people say that the Devil was born at this hour and also the place where Moses was buried and the ram that Abraham slaughtered instead of Isaac. ☆ The Pirkei Avot 5:6 enumerates the items that were created between the end of the Act of Creation and first Sabbath. These items were made apart from the rest of Creation because their existence was specific to a single purpose. Their appearance at the preordained moment appeared to be a miracle and inspired all creatures to act in accordance with God's will. The appearance of the ram at the site of the Akedah, for instance, was preordained from the beginning of time, but not known to Abraham until the critical moment. Lieberman has painted the separate elements listed in this text within a screen-like format. They appear to exist in a pocket of space far removed from the earthly sphere until the time of their need arises. The Hebrew alphabet and the Ten Commandments were cut from printed material and applied to the canvas.

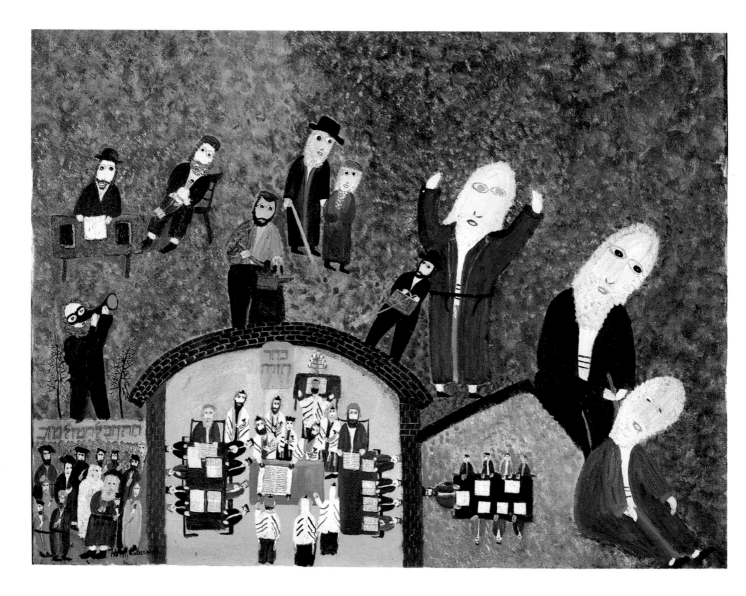

45. *The Ages of Man*, c.1970, acrylic on canvas, 30″ x 40″. (Collection of Helen Popkin) At five years the age is reached for the study of the Scriptures, at ten for the study of the Mishnah, at thirteen for the fulfillment of the commandments, at fifteen for the study of the Talmud, at eighteen for marriage, at twenty for seeking a livelihood, at thirty for entering into one's full strength, at forty for understanding, at fifty for counsel, at sixty a man attains old age, at seventy the hoary head, at eighty the gift of special strength (Psalm 90:10), at ninety he is as if he were already dead and had passed away from the world. ☆ Lieberman refers to Psalm 90:10: "The span of our life is seventy years, or, given the strength, eighty years; but the best of them are trouble and sorrow." The life cycle has been described through a variety of metaphors since ancient times. It is sometimes compared to the four seasons, at other times to a series of steps. It has been broken up into as few as three stages and as many as fourteen, in the Pirkei Avot 5:21. Lieberman illustrates these phases of existence through the life changes of one man. The first three stages are set inside the cheder, the yeshiva, and under the chupa—the marriage canopy. The remaining phases revolve around these structures until we are brought full cycle back to the cheder. But now, the figure is no longer permitted inside the cheder, but must lean, exhausted, against it.

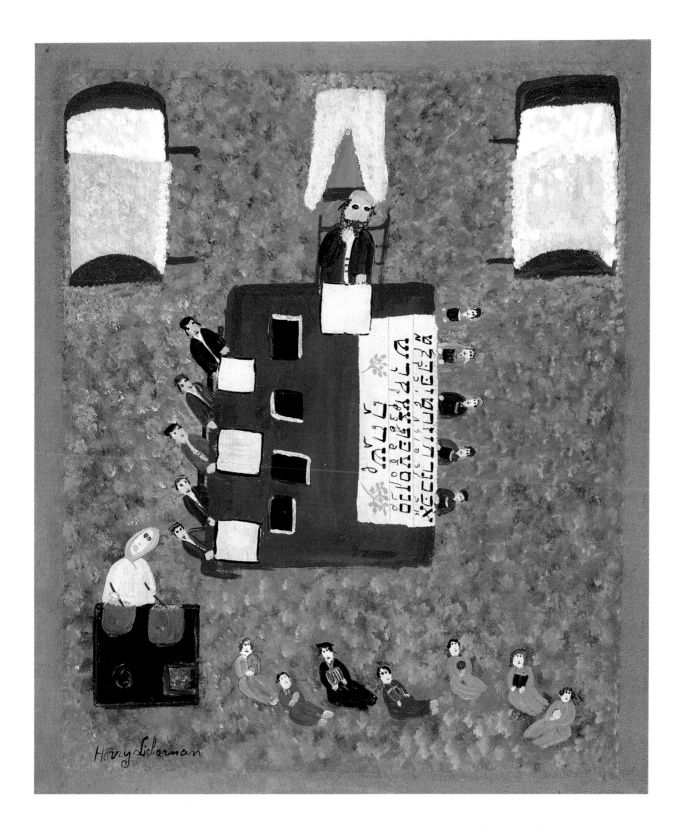

46. *The Wisdom of the Fathers Chapter Five*, c.1970, acrylic on canvas, 24″ x 20″. (Private collection) Eliezer, son of Avioh, said: When a young person learns it is as writing on a new slate—everything remains clear; when an older person learns it is as writing on a used slate—what is there may be unclear and rub off easily. ☆ Lieberman has interpreted this verse from the Pirkei Avot in a literal manner. The children sitting at the table learn the Hebrew alphabet from a clearly printed scroll, while the older scholars have indistinct pages before them. This scene recalls the interiors of Polish cheders or Hebrew schools for young children. A Hasidic discussion asks, "Why discourage the older man?" and interprets this verse as a style of learning, rather than an age-related ability. Even an old man can learn with the intensity and single-mindedness of a child if he concentrates enough.[45] The characters in this painting seem to stare directly at the viewer from their arrangement around the central table.

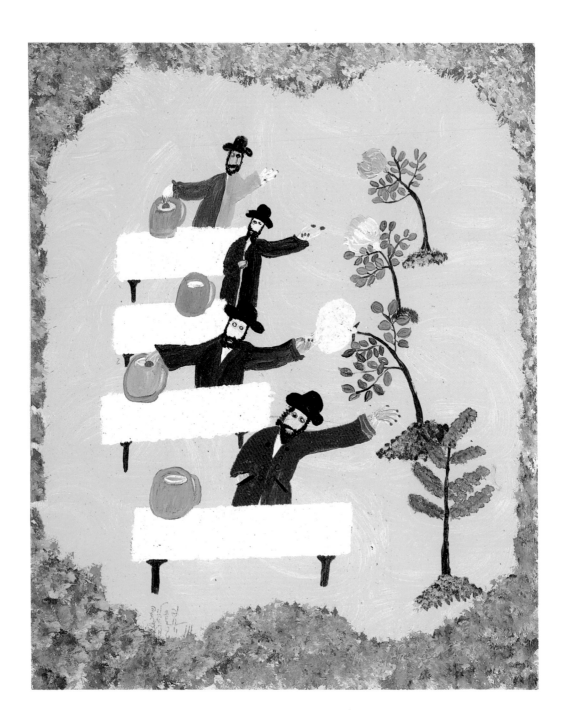

47. *Almsgiving*, 1976, acrylic on paper, 20″ x 16″. (Private collection) As to almsgiving there are four dispositions: He who desires to give but that others should not give, his eye is evil to what apertains to others since almsgiving brings blessing to the giver; he who desires that others should give but will not give himself, his eye is evil against what is his own; he who gives and wishes others to give is a saint; he who will not give and does not wish others to give is a wicked man. ☆ This text comes from the Pirkei Avot 5:13. It is part of a series of discussions on the nature of man united by the use of the number four. The Baal Shem Tov commented that there may be only three dispositions of almsgiving, as the last man does not give at all. He explains, "One is the chair upon which the other sits; one is like the man who holds an object in his unpraised hand, the other is like the object thus held. In the same way, the uncharitable man is the chair on which the charitable sits; or the hand which raises up the uncharitable."[46] The first two almsgivers are shown with two-toned coats suggesting their divided intentions. The first dips one hand into the charity pot, but cannot reach the Tree of Life; the second holds one hand close to his chest and the other extends towards, but does not reach, the Tree. The third almsgiver is dressed as a Hasid and gives to the charity fund with his right hand, and touches the Tree of Life with his left. The last almsgiver keeps one hand in his pocket and raises his other hand towards a palm tree, which he cannot reach. In mystical literature, the palm tree represents the mystical text "Tomer Devorah," or *Palm Tree of Deborah*, which instructs every Jew in ethical behavior to achieve spiritual identification with the ten sefirot.

CHAPTER IV

SYMBOLS AND SOURCES

SYMBOLS

Lieberman's paintings are steeped in the lore and culture of his Hasidic life in Poland. Much of the symbolism contained in his paintings derives from the traditions and rich mythology associated with Hasidism.

In the text that accompanies the painting "When I Was Ten," Lieberman writes, "I remember when a rabbi from a neighboring town came to visit my town of Gniewoszów. Everybody in my town went to the forest with the rabbi. I went also. It is a Kabbalistic idea that the rabbi gains a spiritual lift from being in the forest with us."[47] As a child, Israel Baal Shem, the founder of Hasidism, would study with his teacher, but after several days, he would run away and be found sitting alone in the forest. Elie Wiesel relates that, "When the great Israel Baal Shem Tov saw a misfortune threatening the Jews, it was his custom to go into a certain part of the forest to meditate. There he would light a fire, say a special prayer, and the miracle would be accomplished and the misfortune averted."[48] The idea of entering the forest as a place of spiritual refuge and communion is evident throughout Lieberman's paintings, usually in the forest trees that play around the fringes of a scene or that border certain passages of the composition. The forest bestows a frame of sanctification around the action of the paintings and provides a ladder into God's house in the upper world, protected by a blanket of blue sky. The forest becomes the conductor through which the "Divine Sparks" can be received by the Hasidim below. The triangular form of the trees recalls the ten sefirot, which are usually presented collectively in a diagrammatic scheme known as a "cosmic tree" or "tree of emanation," the overall structure of the "tree" built from connecting

triangles. In conjunction with other Hasidic and Kabbalistic symbols—the hovering angels, the Heavenly Tribunal—the paintings become an allegory of Hasidism presented in a symbolically unified whole.

The Heavenly Tribunal that records each person's deeds and sits in judgment at the Day of Reckoning appears in many of Lieberman's paintings (fig. 62). According to the Pirkei Avot 2:1, above is "An eye that sees, an ear that hears, and a book in which all your deeds are recorded."

The color blue, frequently seen in Lieberman's paintings, has many symbolic associations in Jewish folklore and tradition. According to folklorist Raphael Patai, the sky is often considered a symbol of the "upper waters"—a symbol of God's house.[49] In some communities, doorposts of homes were painted blue for protection against the evil eye, just as God had painted his own house—the sky—blue. The cover for the Ark of the Covenant was blue, as were the tabernacle hangings. The garments of Aaron the Priest became the colors of "holy garments"—blue, purple, crimson. In the Bible, it was commanded that a cord of blue be appended to the four corners of every garment worn by man as a reminder of Israel and the commandments. Maimonides wrote, "Our Rabbis explained that the blue is like the sea and the sea is like the firmament, and the firmament is like God's Throne of Glory."[50]

Lieberman's overwhelming use of the color blue contributes yet another component to the Hasidic domain he has created in his paintings.

SOURCES

Wertkin and Kleeblatt write, "While folk art in general tends towards abstraction and two-dimensionality,

within Jewish folk art these conventions have a religious base, and thus permit the artist to transfer imagery from the real world and move it into the realm of symbols."[51] This two-dimensionality is readily apparent in many of the visual sources that were available to Jews throughout the European diaspora.

Among the earliest examples were medieval illuminated manuscripts. Gabrielle Sed-Rajna writes that, "…at no time during the history of Judaism was the language of form excluded, provided it was used as a teaching medium or for embellishment."[52] Consequently, there exists a rich body of adorned literature based on the Bible and the vast number of exegetic texts. According to Wertkin and Kleeblatt, "…the word, decorated and adorned, lies at the very heart of Jewish folk arts."[53] Lieberman's use of text on the face of paintings such as *The Wisdom of the Fathers Chapter Five* (fig. 46), as well as his written explanations found on the back of his canvases, are consistent with a well-established tradition of Jewish visual representation.

The geometric and sequential nature of many of Lieberman's paintings may derive from any of a number of visual forms. Itinerariums, for instance, which date back to at least the sixteenth century, were graphic catalogues of Jewish sites in the Holy Land. Used by pilgrims to the Holy Land, they served a dual purpose as guides to specific places and souvenirs upon a traveler's return. Originally, the sites were organized geographically. By the nineteenth century, the images had become standardized in two-dimensional, schematized form, and were arranged in geometric rows. This arrangement recalls many of Lieberman's canvases, such as *There Is Always Hope* (fig. 60) and *Bunche the Silent* (fig. 62), where action is arranged in a linear progression on a series of tiers. It must also be remembered that Lieberman did not start to paint until after his trip to Israel. There is little doubt that he visited many of the sites represented in these itinerariums, and may have visited some early synagogues, such as the Beth Alpha synagogue, which contains highly celebrated floor mosaics (fig. 48). Lieberman was aware of this synagogue through books on Jewish art such as Cecil Roth's *Jewish Art: An Illustrated History*. This book remains in Lieberman's home and the illustration of the Beth Alpha Zodiac floor mosaic is still marked with a yellowing scrap of paper. The resemblance of Lieberman's painting, *Calendar for 1971* (fig. 63), to this mosaic is unmistakable.

Decorated forms commonly found in East European Jewish homes and synagogues included the papercut or colored "mizrah" that was hung on the eastern wall to indicate the direction one should face during prayer, and the "shiviti," a devotional wall hanging that derives

48. *Floor Mosaic: Beth Alpha Synagogue*. Photograph courtesy the Institute of Archaeology, Hebrew University, Jerusalem, Israel. The depiction of the zodiac as part of the decoration of a synagogue is not an isolated representation, but occurs in several other instances. Lieberman has used it as the model for his painting, *All the Days* (fig. 63). The ancient Hebrews may have been introduced to the zodiac by the Romans, but never as a form of worship. The Talmud states, "Our rabbis taught, He who sees the sun at its turning-point, the moon in its power, the planets in their orbits, and the signs of the zodiac in their orderly progress should say: Blessed be He who has wrought the work of creation."[54]

from Psalms 16:8: "I am ever aware of the Lord's presence." Lieberman was clearly influenced by his memory of these forms in his painting *God, Hear My Voice* (fig. 4), which exhibits many of the same elements found in a late-nineteenth-century lithographed mizrah from Jerusalem featuring the "Akedah," the "Binding of Isaac" (fig. 49). The exact same scene is represented on a late-nineteenth-century perforated-paper embroidery from Jerusalem (fig. 50).

Lieberman frequently asked his family to find source material for his depictions of animals, costumes and scenery. In compliance with his wishes, the family purchased volumes of children's illustrated encyclopedias, Alfred Rubens's *A History of Jewish Costume*,

49. *Mizrah*, Moses ben Yitzhak Mizrahi, Jerusalem, Israel, 1888, lithograph, 18″ x 22½″. Photograph courtesy Art Resource, New York. (The Jewish Museum, New York; Gift of Dr. Harry G. Friedman) A "mizrah" (East) is a decorated paper form that indicates the direction to face during prayer. Many Polish mizrahim were made of hand-painted cut-paper designs. This late-nineteenth century lithographed mizrah, or a similar example, may have served as the model for Lieberman's painting, *God Hear My Voice* (fig. 4). The arch overhead, the emblems of the twelve tribes of Israel, the columns on either side and the trees in urns are all visual elements that are reinterpreted in Lieberman's painting.

and other books that were profusely illustrated but lightweight enough for Lieberman to hold comfortably.

Although Lieberman did not consciously adopt a "symbolic" language, individual elements of his paintings, such as people, trees, flowers, and buildings, are usually stylized representations that are repeated from canvas to canvas.

His paintings of people reveal totemic figures with otherworldly eyes. They are rarely individualized portraits, but an identifiable cast of characters that we meet over and over again from canvas to canvas. We quickly begin to recognize the rabbis and the Hasidim, the water carriers, the tradespeople, the craftsmen, and the women, always busy at cookpots or tending children.

His architectural structures are essentially stage sets that merely provide contexts for the events of the painting. With a few deftly painted details, Lieberman creates the flavor of the wooden buildings of a shtetl, arranged around a large, open central area. The accuracy of these depictions is astonishing when one compares a photograph of an actual shtetl (fig. 11) with Lieberman's paintings (fig. 59).

50. *Embroidery*, Frieda Leah Shifman, Jerusalem, Israel, 1899–1900, perforated paper embroidered with polychrome wool, 48.5 cm x 60.5 cm. Photograph courtesy Art Resource, New York. (The Jewish Museum, New York; Gift of Deanna Hausner) Embroidered punched-paper patterns based on biblical themes were popular Jewish needlecrafts at the end of the nineteenth century. The scene depicted on this panel is almost identical to that on the printed mizrah of the same period (fig. 49). The two-dimensional and sequential format and the incorporation of Hebrew text into the face of the design are elements also seen in Lieberman's paintings.

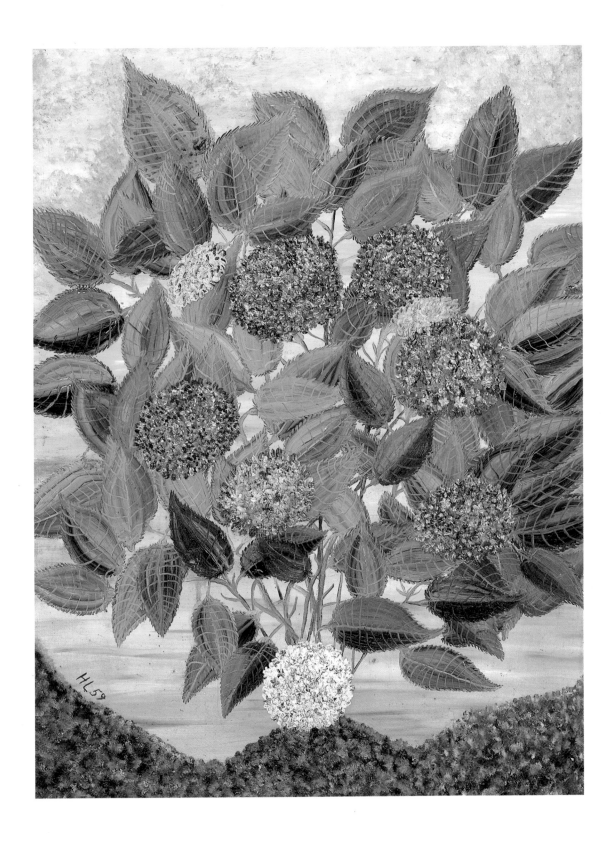

51. *Hydrangea*, 1959, oil on canvas, 24″ x 18″. *(Private collection)* Lieberman's first drawing attempt was of a pot of philodendrons at the Great Neck Senior Citizen Center. He loved painting flowers and continued to do so throughout his career, depicting his own gardens or the bouquets of flowers that family and neighbors regularly brought him.

52. *Figures*, 1965–1975, acrylic on self-hardening clay, 8″ to 12″ high. (Private collection) Lieberman made less than fifty of these single figures. They are solid clay and represent characters from the shtetl, prophets of Israel, kings and queens. Before he switched to self-hardening clay, some of his earlier figures shattered in firing. He later repeated many of the same themes. Some of the figures have hats that were made separately.

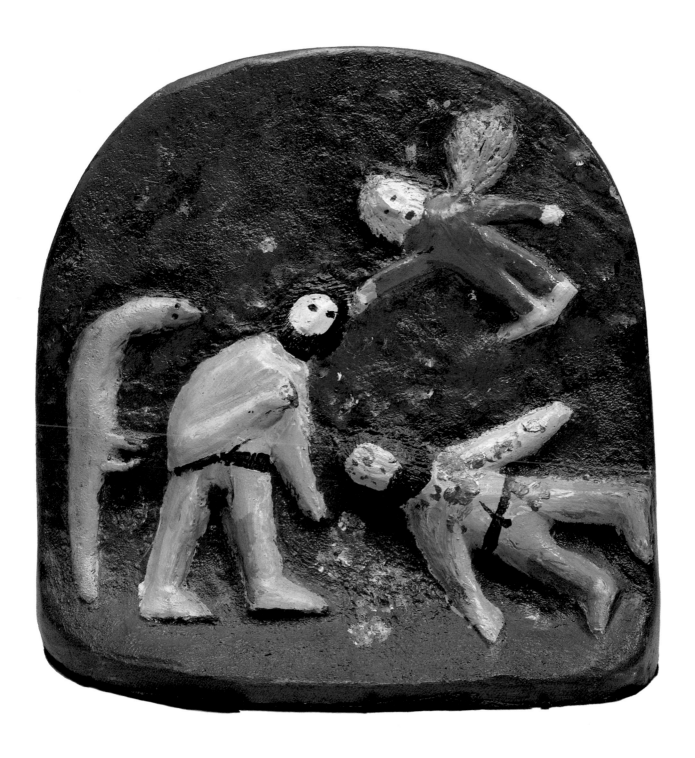

53. *Plaque: Cain Kills His Brother Abel*, c.1976, acrylic on self-hardening clay, 10″ x 10″ x 4⅜″ deep. (Private collection) Lieberman used the three-dimensional medium of clay much as he used paint. Although the figures are in relief, they maintain the abstract quality of his painted figures. Many of the scenes he created in clay were also executed in acrylic paint, such as this scene of Cain and Abel.

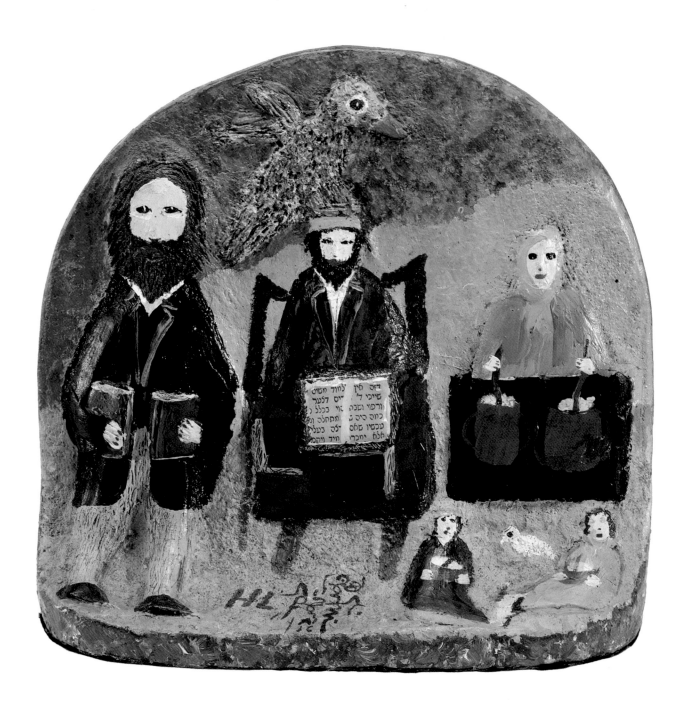

54. *Plaque: Untitled (The Pious Fool)*, c.1976, acrylic on self-hardening clay, 9½″ x 10⅛″ x 4⅛″ deep. (Private collection) The Talmud calls a man who studies and does not take care of his family a pious fool. So also, the philosopher. Even the eagle must come down to earth to get food. So must the pious man and the philosopher tend to the needs of the earth. Heaven does not feed us while we are here. ☆ Stories of this nature appealed to Lieberman who was always critical of "religious fanatics." The practical aspect of Judaism urges that the needs of this world be met so that one can aspire to the rewards of the next with a clear conscience.

55. *Drawing*: Untitled, no date, pencil on paper, 16¹⁵/₁₆″ x 14⅛″. (Private collection)

SINCE THE BEGINNINGS OF TIME, MAN HAS FOUGHT, HAS KILLED HIS FELLOWMAN. ISNT IT TIME THAT HE LIVED IN PEACE? DID WE NOT LEARN A LESSON AFTER HITLER? WE ARE CIVILIZED, OR SO WE SAY. WHEN THE PROPHET ISAIAH SAID "WHEN THE WOLF AND THE LAMB SHALL EAT TOGETHER, AND THE LION AND THE BULLOCK." DID HE MEAN THAT THEN THERE WILL BE PEACE?

the Lion shall like the BULLOCK eat straw

The wolf shall eat and the Lamb together

the serpent dust shall be his food

They shall not hurt nor destroy in all My holy mountain SaiTH THE LORD.

56. *When the Messiah Comes*, c.1981, ball-point pen on paper, 16¹⁵/₁₆″ x 14⅛″. (Private collection)

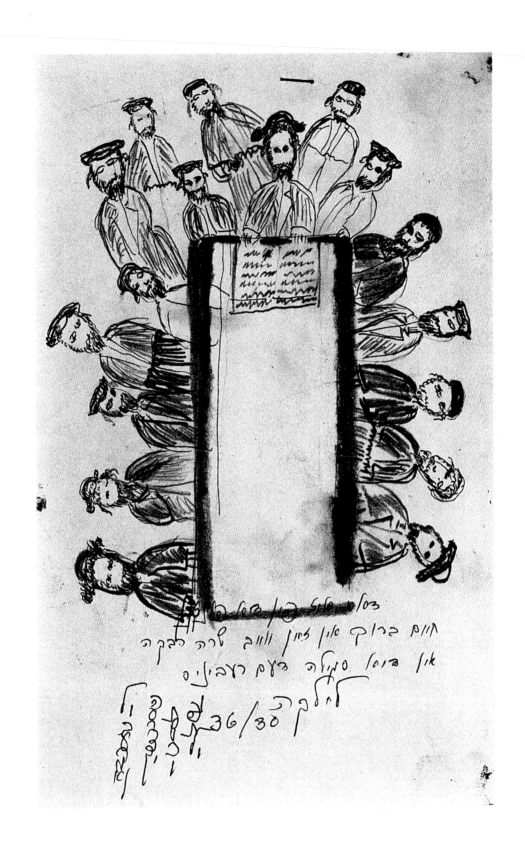

57. *Scholars,* no date, pencil on index card, 8″ x 5″. (Private collection)

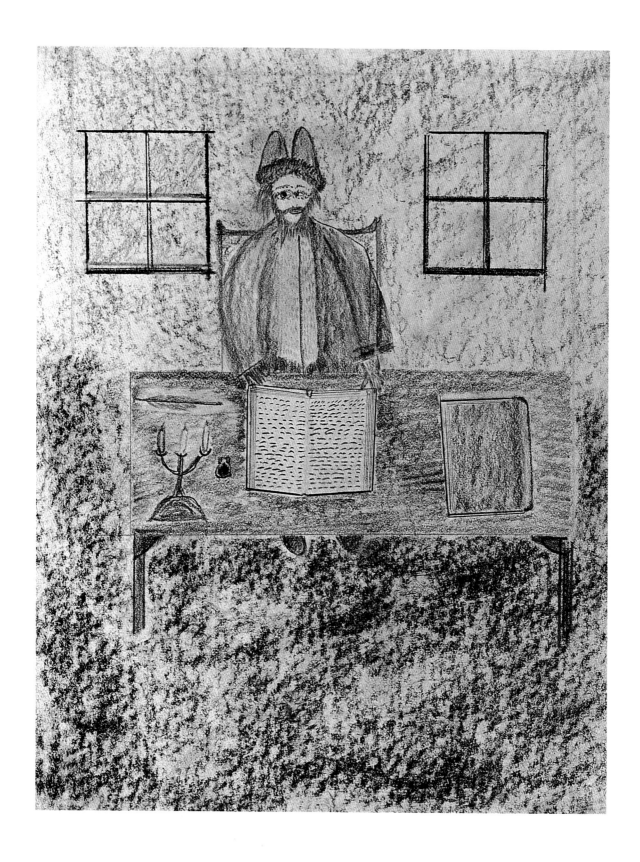

58. *Rabbi at Table*, no date, pencil and charcoal on cardboard, 9⁷/₈″ x 7⁹/₁₆″. (Private collection)

Lieberman executed sketches in pen, pencil, and charcoal throughout his career. He worked on bound pads, index cards, scraps of paper and cardboard and considered each sketch a finished work. Although many of the sketches are minimal representations, others are fully developed scenes similar to his painted compositions.

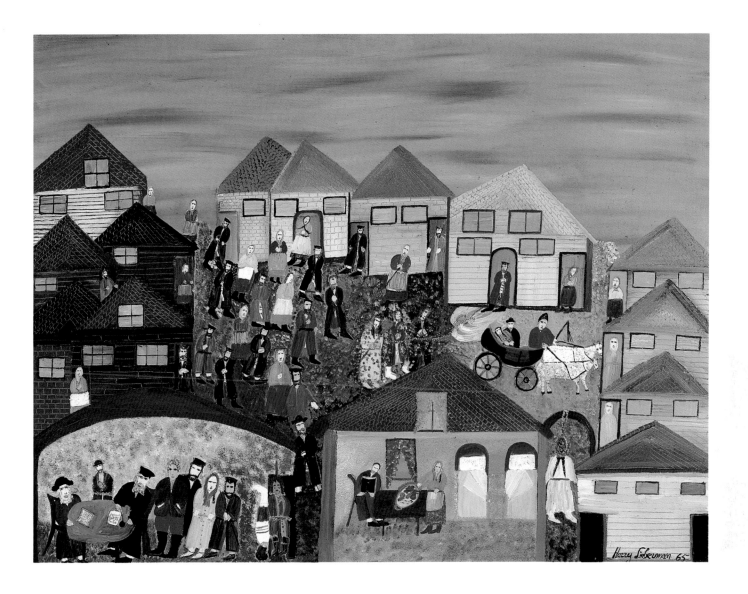

59. *The Sect of Sabbatai Zevi from a Book by Isaac B. Singer,* 1965, oil on canvas, 30″ x 40″. (Courtesy the Morris Gallery, New York) Once in a town there lived a rich man named Gimpul, on whom the whole town depended. His daughter, Elizabeth, was married to a man named Solomon from a Satan-worshipping sect. Solomon introduced his wife to another man, knowing that she would have an affair with him. After this took place, Solomon went to the rabbi to report his wife's infidelity. The rabbi and the council decided that he, his wife, and the man would have to walk through the town while the townspeople cast dirt on them. When this had been done, Elizabeth, on reaching her home, hung herself in disgrace. Her father returned to the town from a trip to find that his daughter was dead, and he left the town forever, and it became a desolate ghost town. The husband has never been heard from again. What was the benefit of the rabbi's decision? ☆ The profound belief in the coming of the messianic age has at times made Judaism vulnerable to false messiahs. This story is an allegory based on the havoc wreaked by the most notorious of the pseudo-messiahs, Sabbatai Zevi. In 1665, Sabbatai Zevi declared himself the Messiah and began to issue a series of messages that were joyfully received among his followers. His marriage to an orphan of the Chmielnicki massacres that took place in Poland in 1648–1649, and the enthusiasm of respected religious leaders encouraged a growing belief that the Messiah had actually come. Some Jews even sold all their worldly belongings in anticipation of the Messianic Age. In 1666, the Privy Council of the Sultan in Adrianople, alarmed by the disturbances in the Jewish world, offered Sabbatai Zevi a choice: execution or conversion to Islam. When he chose conversion, he left the Jewish world in a state of devastation. Sabbatai Zevi's name is still anathema to the Orthodox Jewish community.

60. *There Is Always Hope*, 1966, oil on canvas, 40″ x 51″. (Private collection) Lieberman recounts a story by I.L. Peretz called "Devotion Without End." Once there lived a wise rabbi, Rabbi Cheyu, who lived by the shore of the sea. This man had only one child, a daughter named Miriam. After his wife's death, Rabbi Cheyu turned his villa into a yeshiva of which he was the headmaster. He took in many young men to be taught and thought it would be good if one of these young men was the right husband for Miriam. One day, Rabbi Cheyu heard a commotion outside his study. He found his assistant arguing with a wild boy dressed in the skin garments of a desert wanderer. The boy threw himself at the rabbi's feet and begged to be admitted into the yeshiva. But the rabbi asked, "Do you know the Torah or the Talmud or the Mishnah or the Gemara?" The boy answered, "No, I do not know them, but maybe if I come and sit by your feet I will remember." The rabbi was very puzzled and asked what he meant by"remember," and the boy reluctantly told him what had happened to him. "Once I was the son of a wealthy woman in Jerusalem. I went to the best schools and gymnasia and yeshivas and was always on top of my class. But I was very proud of my knowledge and I would go around to other schools and debate, not to discover the truth, but only to show that I knew more than anyone else. One day I heard that there was to be a wedding between the daughter of a very wealthy butcher, who was a very mean and wicked man, and a wild boy of the desert who had been taught by the great Elisha and was very learned and was thought, therefore, to be the finest match the girl could make. I went there and argued with the young man after he made his speech before the wedding, and I showed everyone that he was ignorant, and the butcher took the groom and threw him out of the house and called off the wedding. Then I knew I had done too much because of my pride, but I could not undo it. Then I met the Rabbi of Jerusalem and he cursed me for what I had done and said that I should forget all I knew, and so it happened. And he said that to be free of the curse I must change clothes with the desert boy and give him my sister in marriage, and I myself must become a desert wanderer until he appeared to me in a dream. I wandered like this for two years, and now that rabbi has come to me in a dream and told me to come to you and your yeshiva to be saved." One day, Rabbi Cheyu was walking in the garden and he overheard two serpents conversing. One snake asked the other what he was doing there, and didn't he know that he could harm no one there because of the great rabbi, Rabbi Cheyu who was in charge of the yeshiva and protected everyone there? But the poisonous snake replied that he was sent by the Angel of Death, himself, to kill the wild boy eight days after his wedding. "What wedding?" asked the first, and the poisonous serpent told him the wild boy would marry the rabbi's daughter. Rabbi Cheyu was very disturbed and called his daughter and asked her which of all the boys in the yeshiva she would like to marry, and she named the wild boy. When her father asked her "Why?," she said anyone who could study and learn and not pay attention to the insults of the others about his clothing, as he did, must have a very good character. Also, she told him of a time when all the other students had gone with the rabbi on a boat trip, but he had stayed behind for fear that she would be left alone. But they had never spoken. And Rabbi Cheyu told Miriam of the conversation of the snakes and that if she married him, he would die in eight days. But she said she loved him and would try to help him, and so they were married. And on the eighth day, Miriam put on her husband's garments and went out into the garden. She met the serpent and he bit her and she died. When she reached heaven and the mistake was discovered they were going to return her, but she refused to return to life except upon the condition that the death sentence and the curse upon her husband be completely revoked. And so it was, and they lived together long and happily. ☆ This story has all the elements of a classic fairy tale: the hero who falls under a curse, the heroine who falls in love with him despite his disguised state, and the defeat of the curse through true love, purity, and sacrifice. The snake has represented evil since Adam and Eve's expulsion from the Garden of Eden. Some folkloric literature interprets the snake as the source of all evil inclination in man. It is the responsibility of all Jews to help the "good inclination" hold sway over evil. Lieberman has divided this story into three visual levels with self-contained units illustrating the dramatic action: the story of the young man's growing pride and fall from grace during the marriage ceremony (the bride and groom stand under a chupa or marriage canopy); the pivotal boat trip during which he stayed with the rabbi's daughter and won her affection; his redemption of self through hard work and Miriam's love and sacrifice. Lieberman uses the ladder in the boat as a visual aid in linking the second level of the painting to the concluding scene, while above all the earthly action, the "Heavenly Tribunal" records all their deeds for judgment in the life to come. The spiritual forest surrounds the yeshiva of Rabbi Cheyu, while the Tree of Life grows near the Jerusalem Rabbi.

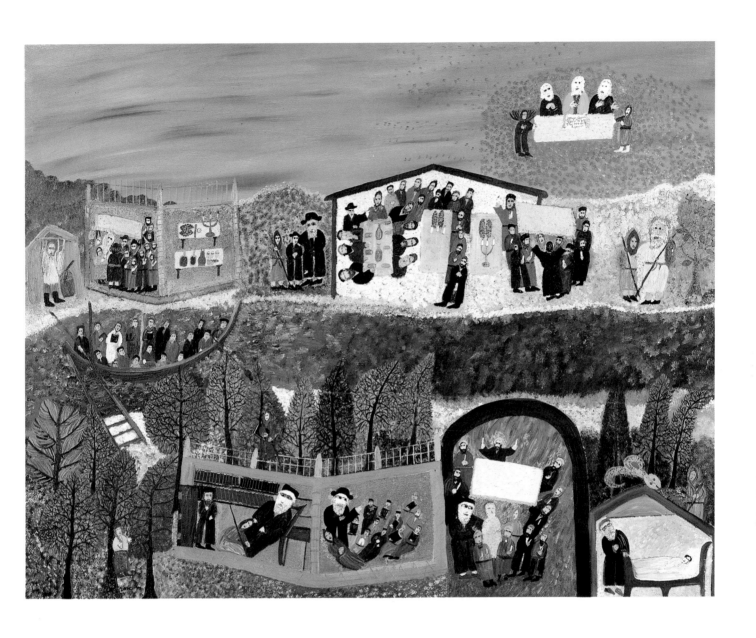

61. *The Generation Gap* (from I.L. Peretz), 1966, oil on canvas, 30″ x 40″. (Private collection) If Peretz were alive today he would speak for youth. He tells of a town that had a drawbridge pulled up at night so no one could come in and no one could leave. The young man returning late to the town had to sleep in a field. He had a dream in which he spoke to a man in the town who was little respected because he was a "freethinker." In the dream, the freethinker said there would come a day in which people would be born with wings so they could soar high. Now, the young man realized he would stifle in this town so he left to seek his fortune. After some years, he realized all towns were much the same so he decided to return home. On the way he stopped at an inn and found that a child had been born with wings, according to the people in his dreams. He was elated. "Now man will be able to soar high," he said, but the elders in the town said, "That's bad. To succeed a man has to keep his feet on the ground." ☆ Peretz was one of the foremost Jewish writers in the Yiddish language. He was raised as a Hasidic Jew and his stories seem to capture the essence of Hasidic life, as well as the changes that were being introduced through the secular movement known as Haskalah. In many ways, this story parallels Lieberman's own life and yearnings. Lieberman refers to himself as a "freethinker" during the years he rejected the religious practice of Judaism. He, too, felt stifled by the narrow life of the shtetl and came to America to seek his fortune. He uses this story to illustrate the dichotomy between the older, strictly Orthodox, generation and his own restless generation. He expresses his own ambivalence towards a religious life that superficially restricted individual choices and the life of a "freethinker," which offered no spiritual foundation. The Pirkei Avot 3:13 says, "Tradition is a protective fence about the Torah." Lieberman has painted a self-enclosed village adrift in a blue sea. The only exit is a huge gate that bridges the gap between the village and the sea. This gate is kept open by a tremendous anchor, but all the elders of the village huddle in the shadow of the gate with the old-fashioned traditions that keep them rooted to the ground.

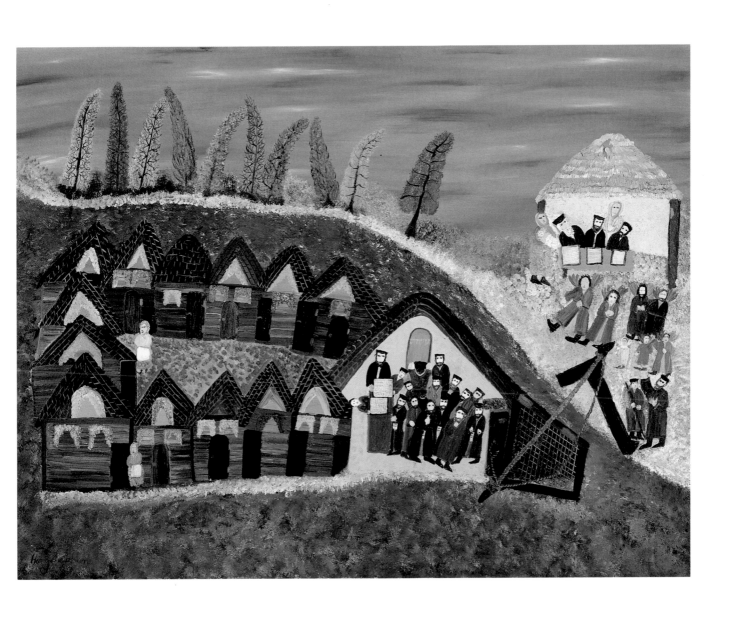

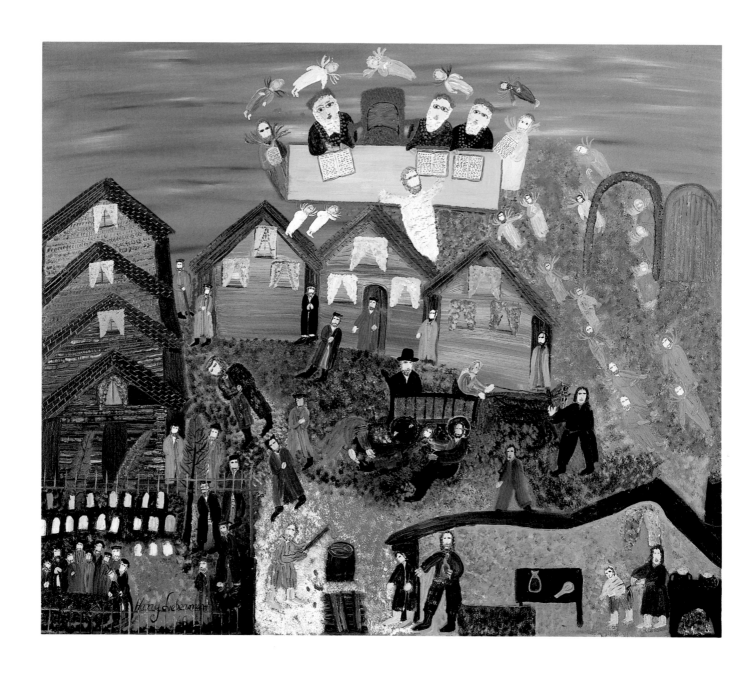

62. *Bunche the Silent* (from I.L. Peretz), 1966, oil on canvas, 30″ x 36″. (Private collection) When Bunche was small, his stepmother hit him. When he was larger, his father beat him and sent him out barefoot into the snow. He chopped wood. When he was older, he carried wood for the town. He was paid only sometimes, but never complained because he felt it was fate. He stepped in the street rather than on the sidewalk when people passed and got splashed with dirt. Once, a horse ran wild on the street and a man was killed. Bunche tried to soothe the horse but was hit too. He was taken to the hospital but never complained. He died and the angels came from heaven to guide him to the judges. The judges told him that he was a wonderful man and told him that he could have anything he wanted. He said, "I want a fresh roll and butter for breakfast every day." ☆ This painting is based on one of I.L. Peretz's best-loved stories. Lieberman presents the heartbreaking tale of Bunche as told through the Heavenly Tribunal's review of the Book of Deeds. The Tribunal, surrounded by orders of angels, looms over the world below, which is seen as from a great distance. Bunche's life of abuse and uncomplaining selflessness is organized as a series of events that transpire from right to left. The angels come for Bunche's soul and enter through a heavenly gate that separates the spheres of this world and the upper world.

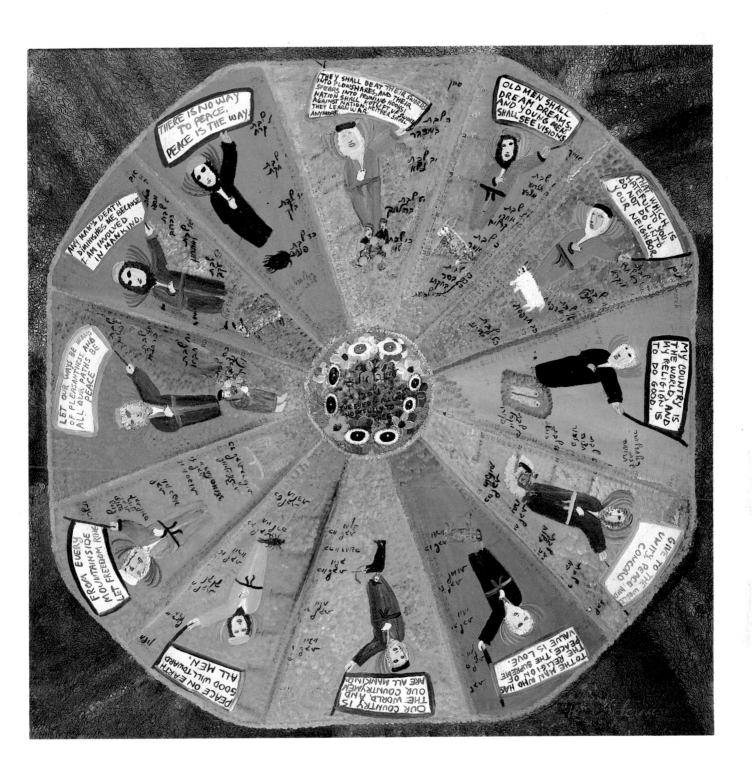

63. *Calendar for 1971*, or *All the Days*, 1971, acrylic on canvas, 30″ x 30″. (Private collection) There are twelve months, twelve tribes, and every tribe has its emblem. In the center is represented the source of everything: "The eyes of all look hopefully to thee." ☆ Lieberman planned the composition of this calendar around the Jewish liturgical calendar, including the weekly Torah portions and the names of the Hebrew months. The banners are held by the winged prophets and sages: Hillel, Isaiah, Joel. Some are Biblical quotes, appropriate to the holidays observed in that month. The holiday of Simhat Torah, for instance, is celebrated in the month of Tishrei, and the quote is the directive to follow in the ways of the Torah. Lieberman relied on his granddaughters' help in selecting the secular quotations. The signs of the zodiac are presented as the emblems of the twelve tribes of Israel. The overall format of this calendar is clearly based on the prototype found in the Beth Alpha synagogue (see fig. 48), but Lieberman has not included the attributes of the seasons in the four corners. The Beth Alpha synagogue is arranged in four groups of three, corresponding to the arrangement of the twelve tribes of Israel described in Numbers, chapter 2. The zodiac was a favorite motif in the decoration of Polish synagogues of the seventeenth and eighteenth centuries.

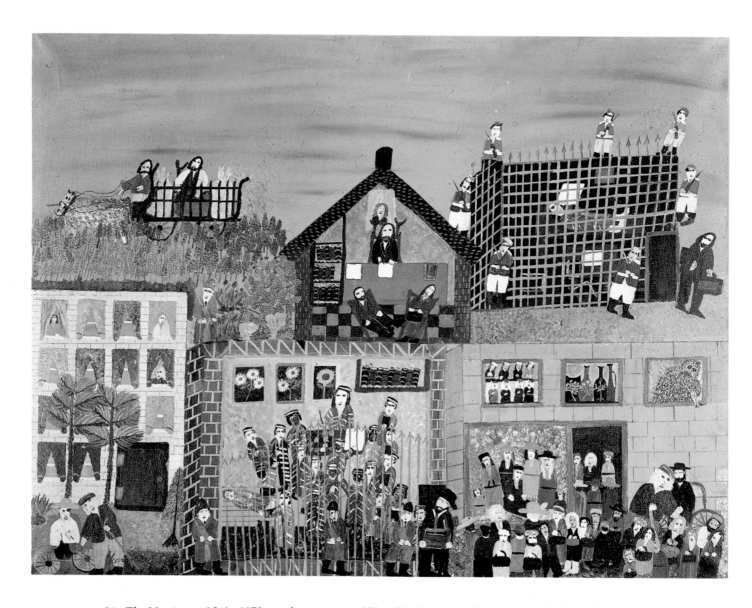

64. *The Mystique of Life*, 1972, acrylic on canvas, 30″ x 40″. (Museum of International Folk Art Foundation, a unit of the Museum of New Mexico, Santa Fe. Purchased with the aid of funds from the National Endowment for the Arts and the International Folk Art Foundation) This painting is divided into six sections, each with an individual story. The unifying theme is one of self-help through inner resolve, cooperation, optimism, and acceptance. Lieberman writes, "it is this having something to live for, something to do, that makes a man want to continue to struggle to live, and this is the mystique of life…no matter how bad it is, firstly, it could be worse, and secondly, if I can't do anything for myself, at least I hope I can do something for somebody else."

CHAPTER V

DEVELOPMENT IN LIEBERMAN'S PAINTINGS

When he began painting at the Golden Age Club, Lieberman relied heavily on the still lifes that Jeanne Barron set up for each class. As he experimented with different mediums, colors, forms, and compositions, he gained enough confidence to paint from his own imagination and the first themes he turned to were scenes from his own life. As he returned to those early memories, the strong emotions associated with family and incidents from the past seemed to open a floodgate of sensations that had been repressed for so many years. Lieberman delved into the seemingly inexhaustible well of biblical stories, Hasidic sayings, and the increasingly complex commentaries he had studied in the Talmud. His paintings began to sway with the rhythms of Hasidic culture as he recalled men at prayer or performing the daily rituals of their lives—Hasidic figures dancing across the surface of his paintings.

Lieberman did not paint religious themes indiscriminately, but chose those episodes that echoed his own perception of the world. Nor did he limit himself only to works based on his extensive religious grounding. Lieberman painted stories culled from the Yiddish writings of authors such as I.L. Peretz and Isaac Bashevis Singer (figs. 59-62). He was also aware of world and national events and used his canvases as a forum for his own reflections on those events (fig. 34).

Each of Lieberman's early works presented a new challenge in terms of perspective, anatomy, composition, and narrative quality. In the true tradition of the folk artist, Lieberman devised a formulaic approach to solve these problems. His lack of technical ability never limited the scope of his compositions. Instead, he used anecdotal details and his own visual logic to compensate for technical shortcomings. As a result, the viewer

has no trouble reading the interiors presented in paintings such as *Happy Art Thou* (fig. 43) despite the physical impossibilities of Lieberman's depiction.

His canvases are a marvel of mixed perspectives and outlandish scale. The objects that are the most important are presented as the largest, providing an internal hierarchy that enhances the dramatic purpose of the scene, as in *The Strength of Love* (fig. 40).

Architectural structures are presented from the exterior and the interior simultaneously. Lieberman created a schematic world where nothing was hidden or assumed, but displayed in diagrammatic fashion with three-dimensional form flattened onto the two-dimensional surface. He manipulated space as if it were a cardboard box—he cut the corners and flattened down the sides (fig. 30). At other times, architectural forms appeared as bare outlines that served merely to delineate an interior space, often with a door placed in the lower right corner to indicate the entrance into that space.

Ironically, Lieberman approached the three-dimensional medium of clay as if it, too, were two-dimensional. His sculptures have been called "paintings in clay," and that is, in fact, what they are. Lieberman was not schooled in the proper preparation of his materials. His family recalls the time he gave a clay piece to a neighbor to fire in her kiln. He had not pounded out the air bubbles and when she opened the oven door, his neighbor found the sculpture in fragments. She collected these shards and apologetically returned them. Never one to accept defeat, Lieberman insisted that his granddaughter painstakingly piece together the fragments, which she did. After this incident, though, he switched to self-

hardening clay to create the single figures (fig. 52) and complicated plaques and menorahs that he then painted in bright acrylics (figs. 53, 54).

It is not generally known that Lieberman also drew extensively throughout his career. He filled numerous drawing pads with pencil compositions and drawings executed in ball-point pen. These drawings repeat many of the themes found in his full-scale paintings, but the artist considered them finished pieces and not sketches for painted works (figs. 55–58). He also painted countless pictures of single figures—little rabbis, religious men, flowers, and animals on canvases no larger than 8 X 10 inches and often as small as 3 X 5 inches.

Although it is not possible to date many of Lieberman's paintings exactly, there are certain general conclusions that can be drawn. He started using canvas paper after 1976, when he no longer had the strength to stretch his own canvases. The forms became less precise than they had been and he relied more heavily on scenes he had painted before. The surface of the canvas and paper paintings become increasingly encrusted and luminous and he continued using a scribble technique that revealed a palette of rainbow colors and jewel tones. Although his ability to paint fine details deteriorated, his color sense and compositional qualities remained unimpaired.

In the earliest paintings, disparate elements "float" in space or are presented as contiguous, rectangular shapes that form map-like patterns, such as the interior in the *Birth of a Child* (fig. 14). As Lieberman's confidence and ability progressed, the spaces between these elements became filled with grass, trees, and other devices. By the mid-1960s, the scenes had become more complex and were set into contexts—a marketplace, the shtetl. He started using architectural forms, buildings with peaked roofs that appeared to be stacked on shelves, like the cardboard boxes found in his store. His work of this period assumed a tactile quality, with areas of built-up paint, such as the Torah scrolls in *The Wrong Way of Thinking* (fig. 41), and the tent supports in *The Fruit that Was Brought to Hadrian* (fig. 5).

After the mid-1960s, his paintings began to assume the narrative quality with multitudes of people that is most often associated with his work. The scenes unfold like a panorama within self-contained cells, or along linear progressions that read right to left, like Yiddish and Hebrew. Once they have been understood, Lieberman's paintings of this period become logical and sequential frames within the new set of visual rules imposed by the artist's eye.

Although author and artist Stephen Longstreet called Lieberman a "born colorist," he experimented for several years before he felt free to give rein to his innate color sense. His earliest paintings are almost monochromatic tones of yellow and brown or gray and black, as in *Dig Your Own Grave* (fig. 16). By the mid-1960s his paintings became more colorful and a few years later he switched from oil paints to acrylics because they dried more quickly and he could produce more work, and because they were available in brighter colors. He began a series of paintings that featured rainbow-like borders with rounded corners for which he may have used a template (fig. 42). The border was often striated in tones of pink, orange, and mauve. He continued using painted borders into the mid-1970s, before returning to compositional formats that filled the entire canvas.

After the early 1970s, Lieberman's work took on a new hard-edged clarity with pure colors and graphic forms. The delineation of individual facial features became less defined, the luminous eyes of his earlier paintings, each lash separately painted, became spots of color, the mouths a dab of red paint. Although he still relied on religious sources, he also introduced larger themes—world peace, the Watergate scandal, the Camp David Accords that resulted in a peace treaty between Israel and Egypt (fig. 19). During the last few years of his career, when Lieberman was over one hundred years of age, he began painting in a broader, looser fashion with details less delicately handled and stronger areas of intense color. His hand remained highly practiced but, understandably, less steady.

When he started painting, Lieberman signed his paintings with either his initials or his full name and usually the date. During the middle period, from the late 1960s through the mid 1970s, Lieberman would sign his name, but usually without a date. He occasionally signed his given name in Yiddish, but did not make this a common practice until after 1976. For a short time starting in 1976, he painted a copyright symbol next to his signature.

Lieberman built his own stretchers from pre-cut wood lengths and stretched his own canvases while his strength permitted. Upon the recommendation of an artist friend, he used double-primed linen canvas to ensure the longevity of his paintings. He also made his own wood-strip frames from thirty-foot lengths that he measured and cut himself before nailing them to the stretchers. After 1976, Lieberman started painting on primed canvas bound into pads. He occasionally used these small-format paintings to work out the compositions of larger canvases, and relied on the flat work more heavily as he became unable to stretch canvases.

By 1962, painting in oil, Lieberman began to cover the entire surface of his canvases with blue paint. He prepared around eight canvases at a time with this

characteristic blue background, and simply painted over them if he wanted another background color. He continued this practice even after he changed to acrylic paint and glimpses of the original blue are visible at the edges of forms and in areas, such as windows, that he did not paint over.

After preparing the canvas, Lieberman painted the subject, using paint straight from the tube and mixing colors directly on the canvas. Lieberman also created tones by painting layers of different colors on the canvas and scratching through the layers in scribbled patterns to reveal the colors beneath. He used a sharpened chicken bone as his scratching tool, until his family finally convinced him to switch to a bamboo skewer. The visual effect of these scratched areas was of blended colors that recall the way pointillists depended upon the viewer's eye to mix the points of pure pigment. By the late 1970s, Lieberman's paintings had taken on an almost iridescent quality achieved through the application of layer upon layer of paint, scratched to reveal the rainbow of colors.

When Lieberman first started painting, he worked more than eighteen hours a day on three easels at a time. In his enthusiasm he painted anything and everything. His granddaughter joked that if she and her family had not kept moving, he might have painted them. He didn't paint his family, but his granddaughter relates the story of the time her mother bought a good set of white china—a service for twenty-four—for use on special occasions. Her mother left the house warning Lieberman not to touch the dishes. When she returned home from work, she could not find the china and cornered Lieberman who defiantly, but proudly, led her into the basement where every plate, bowl, cup, and saucer sat drying from the decorations he had just painted!

In his last years, Lieberman could not work more than a few hours at a time. Even when he was not painting, though, he was jotting down ideas and stories for future paintings. He almost always wrote the story of his paintings on paper or index cards in Yiddish and Hebrew. He would attach the paper to the back of the canvas, sometimes with string or staples, and sometimes in an envelope that was taped or glued to the back. He said, "I don't believe a painting should be just a painting. It should have a reason and a meaning, and the painter should let you know what is the reason, and the people who are looking should know what it's all about. My personal feeling is that the artist is the person what gives the message to the world, and I try to make that my paintings show the whole story or idea. But I still put on the back what it is."[55]

65. *Deliver This to Heaven*, 1965, oil on canvas, 30″ x 40″. (Private collection) In Chelm, once, was a cholera epidemic. The rabbinical council met special to think what they could do to stop it. Maybe it was on account people were not obeying God? They decided, we got to go to every house to examine the mezuzah. The Holy Name is written on it. If a letter should drop off, it doesn't work anymore. Next, we should examine the mikvah, the ritual bath for women. If it is wrong there, the women aren't pure and we're all bastards. Meantime, the rabbi died. The council decided to write a note, each should sign, and they will put it in the shroud, and tell to the rabbi, "Remember, you must deliver this direct to the Holy Throne and say if you keep this up, this terrible epidemic, the whole town will die. You got to stop it." Naturally, it stopped, but not for six, eight months. The people of Chelm said, "Nu, so many thousands in line up there, it takes time to reach the Holy Throne." ☆ It is told that when God created the Universe, he sent an angel with two sacks of souls, intelligent and simple, to spread evenly throughout the world. As the angel was flying, one sack caught on the edge of a hill and the simple souls spilled to earth into the town of Chelm.[56] These stories are characterized by the absurd solutions the people of Chelm find to their problems, although the notion of submitting a petition for help to a revered rabbi, even after his death, was founded on actual practice among some Hasidim in Eastern Europe. The petition was rolled or folded and pushed into a crevice of the rabbi's mausoleum. The rabbinical council meets in the arched study in the bottom center of the painting. The peaked roofs of the wooden houses form a zig-zag pattern across the sky. On the lower right, the mikvah is shown in cross-section and the furnace that heats the water spews steam into the bathhouse. On the lower left, the dead rabbi, wrapped in his shroud, is surrounded by the council. A note has been placed under his arm and there are freshly dug graves nearby. On the other side is the cemetery with two rows of headstones, each stone bearing an actual name written in Hebrew.

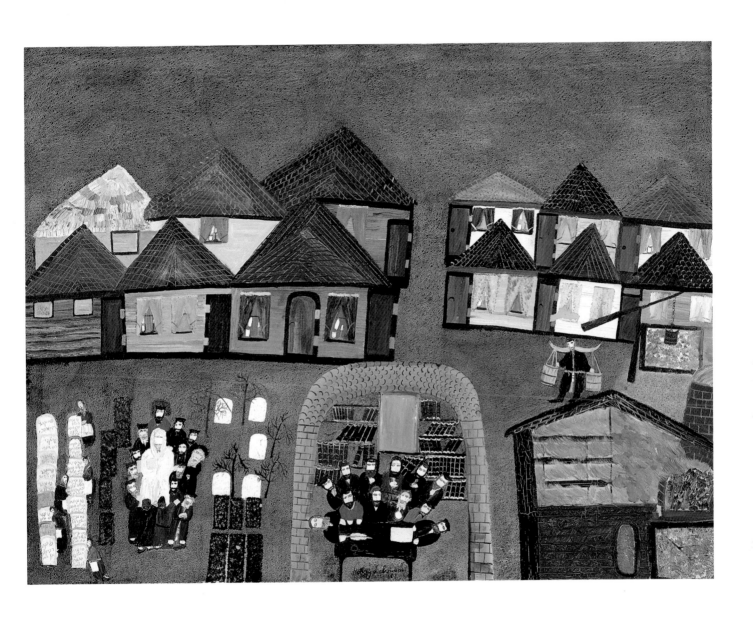

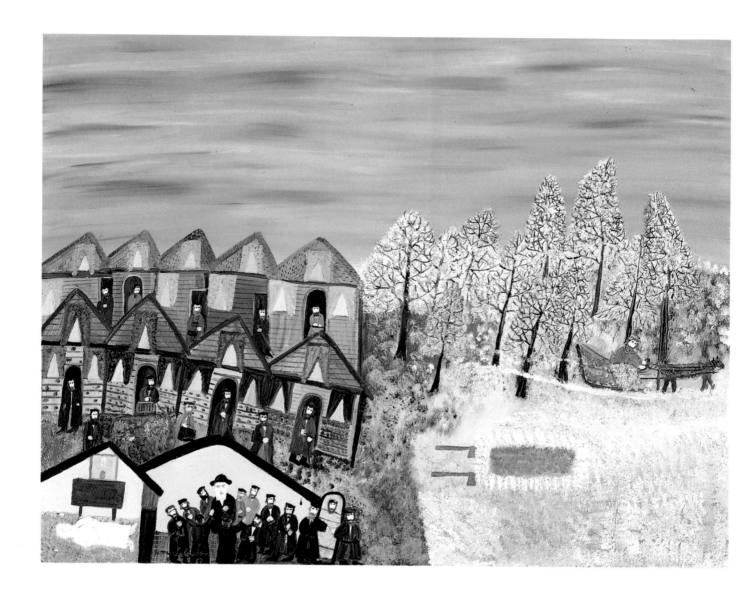

66. *A Litvak in Chelm*, 1967, oil on canvas, 30″ x 40″. (Private collection) After the Litvak had tricked the townspeople with the cure-all egg (another story), the people of Chelm decided to punish him by drowning him in the lake. So they put him in a bag. When they got to the lake, however, they found it frozen solid. In their naturally brilliant way, they had not brought any axes with them, so they could not chop the ice. They left the Litvak at the lake and went back to the town to get the axes. While they were gone, a wagoner passed the lake and heard the Litvak yelling, "I don't want to! I don't want to!" The wagoner approached the bag and asked the Litvak what his problem was. The Litvak told him that the townspeople wanted to make him the town leader, but that he didn't want to be leader. He hold the wagoner that he would let him be leader if he would let him out of the sac and take his place. The wagoner did so, and when the people came back they drowned the wagoner. When the Litvak returned to Chelm sometime later, the townspeople were puzzled that he was still alive. He told them that when he had been put in the lake, he fell to the bottom where he found a city of people who treated him well and gave him treasure. The people of Chelm decided to send someone down to get it for themselves. So they sent the rabbi the same way they sent the Litvak and they are still waiting for him to return. ☆ The folk stories about the people of Chelm are based on the gullible and foolish antics of its townspeople. Often the stories are satirical and goodnatured comments on the superstitious and naïve character of rural communities. The painting is divided into two almost unrelated scenes; the frosted trees and frozen lake, to the right, and the town, to the left.

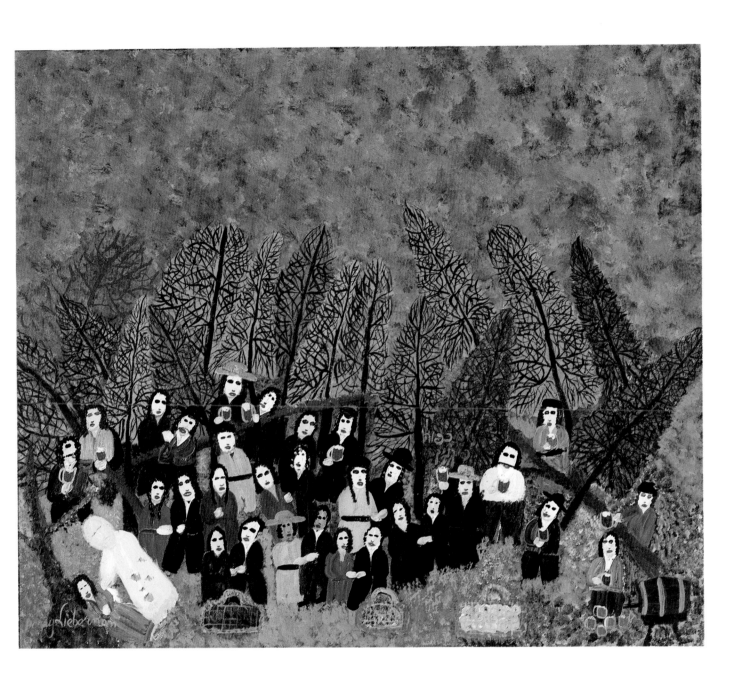

67. *The Dream*, c.1970, acrylic on canvas, 20″ x 24″. (Private collection) A young woman from an Orthodox Jewish house married an atheist. On Yom Kippur, the couple went to a picnic where there was much food and dancing. That night the girl had a dream. Her father came to her and said, "On account of you, my soul cannot rest. See how my clothes are full of holes." ☆ In the nineteenth century, the movement of secular "enlightenment" known as Haskalah encouraged defiance in the face of traditional Jewish rituals. Yom Kippur, the Day of Atonement, is a day of fasting and sober reflection. On this day, one makes peace with all whom he has wronged in the past year, living and dead. The maskilim, or adherents of Haskalah, flaunted this tradition by arranging "Yom Kippur Balls," with dancing and forbidden foods. This gathering takes place in the forest, the spiritual refuge of the Hasid. But broken branches and fallen trees surround this group.

CHAPTER VI

CONCLUSION

Many contemporary folk artists first turn to creative activities after some life-changing situation, such as an injury that prevents them from working, or retirement. Embarking on this next stage of life can precipitate a period of fear and insecurity. It can induce a sense of loss of control over events in one's life and of a reduction of perceived value in the family structure. But this period can also offer the first opportunity since childhood to invest time in pursuits other than earning an income. Sometimes this means resuming an activity that has been practiced at an earlier time; sometimes it means starting something entirely new. Often, whatever form the activity takes, it involves a "life review" on the part of the participant and a way of integrating the past with the present stage of life. Lieberman expressed his own ambivalence toward his retirement years when he said, "Not since I left Poland did I have a chance to take stock on myself. Now I could look around, and I could see that a person is not alive only to make money."[58] But he also remembered those first years of retirement as a time when he, "...had no reason to go to sleep, and no reason to get up in the morning."[59]

Although memories function as an "interior life review," consistent activities and predictable routines can provide the outlet for physical expressions of this life-review process. Lieberman had been retired for six years before he started to paint, and he had established a daily schedule of activities at a senior-citizen center. When this schedule was disrupted through his chess partner's failure to show up at the center, he was safely ensconced in a stable and familiar situation that gave him the courage to try something new and unproven. Because of the rejuvenation he felt as a result of his painting, Lieberman became a strong proponent of continuing education for senior citizens and urged that the senior population be considered a resource rather than a drain. In 1979, Lieberman testified before the House Select Committee on Aging at the invitation of Senator Claude Pepper:

Today I am one hundred and two years of age. Tomorrow is my birthday. I will be one hundred and three. But I don't call myself old. I call myself mature. I'm 102 and I don't think of dying, because I know that I have to die someday. I'm only thinking of living and doing. The fact is, I'm so busy that I think I'm not even "Bar Mitzvah" yet. There is a Yiddish saying, "Don't ask the doctor, ask the sick man." Gentlemen, I speak from my own experience. I was six years retired between the ages of seventy-four and eighty and those were the most miserable years of my life. When I started to paint through the encouragement of a woman instructor at the Great Neck Golden Age Club, it was the beginning of a new life for me. Now I'm not the sick man. Now I'm the doctor and I would like to offer my advice. I do believe the Congress should make a law that in every industry there should be compulsory classes for people over fifty years of age. At least one-half hour a week, instructors should help the employee develop interests and talents they have. This instruction would encourage the people to keep on with these interests after they retire, and maybe even lead to a second career, like mine. I look at my own life experience. I do believe that many of the twenty-five million people over sixty-five years could be productive just like I am—maybe not in art but in all areas—and these people could contribute a lot to this country. We shouldn't throw away these older people. We

should use the knowledge and the experience they have. When Moses complained to God that it was getting too hard for him to take care of over 600,000 men and women in the desert, God answered Moses: "Pick out seventy elders and let them advise, teach, and make decisions."[60]

Lieberman's conclusions about the value of the country's elders echoes those being drawn from projects like the *Grand Generation: Memory, Mastery, Legacy,* sponsored by the Office of Folklife Programs and the Smithsonian Institution. Authors Marjorie Hunt, Mary Hufford, and Stephen Zeitlen consider the "Grand Generation...cultural caretakers. Elderly immigrants," they write, "may face the problem of a past that is entirely interior, with no buildings or landmarks to associate with childhood, and with forebears. The immigrant has to overcome three kinds of distance—spatial, temporal, and cultural, and his expressions emphasize a distinctiveness that is ethnic as well as generational."[61]

As the generation of survivors and immigrants with first-hand memories of life in Eastern Europe ages, many of them have felt the need to preserve their memories as a legacy for future generations. Because much of Jewish folklore is based on oral traditions, this legacy is increasingly imperilled with the passing years. In 1983, Jewish folklorist Raphael Patai noted, "While the great ethnic upheavals in the life of the post-Nazi remnant of the Jewish people hastened the oblivion of the living folklore of the Jewish communities, the study of Jewish folklore progressed at a snails pace."[62] Paintings by artists such as Harry Lieberman and Ray Faust in America, and Natan Heber and David Radovanitz in Israel, have become for all intents and purposes a vital aspect of the "living folklore" of the Jewish community worldwide.

The years that formed Lieberman's basic personality equipped him with the knowledge and training that later proved to be the foundation of his paintings. His paintings conveyed the teachings of his youth and the events of his life in the traditional method he learned as a Hasid. His visual representations of stories that illustrate ethical quandries and issues continued a Hasidic technique of moral instruction through accessible parables; but Lieberman's stories are told in paint, rather than in words.

Although he attended synagogue from 1956 until his death, Lieberman remained as wary of organized religion as he had been when he stopped attending shul in 1906 (fig. 30). Perhaps this affectionate scepticism was responsible for Lieberman's objective eye as he painted the folklore and rituals of Jewish life. He presented Jewish traditions with love, humor, and intelligence, but without the sentimentality and lack of critical faculties that might confine such paintings only to the Jewish community. Their broad appeal lies in their colorful, informative, loving, and literal interpretation.

In 1983, Lieberman stopped painting and his family had to encourage him to eat and to get out of bed. With the same force and determination he had demonstrated all his life, Lieberman seemed to have decided that he was tired. A few months later, he tripped in his home and was hospitalized. On June 3, 1983, the doctors examined him and found his heart strong and his condition stable. They called the family to assure them Lieberman would be fine, but fifteen minutes later, they called again. Lieberman had died of cardiac arrest.

Lieberman said many times, "I myself am not so sure there is a life upstairs, so I feel the life I got now is paradise. My heaven is right down here, because if I am not around, my paintings will be here and people will enjoy my work. That is my hereafter. I don't ask for more."[63]

Lieberman's spirit remains very much alive in his home in Great Neck. Conversations regularly include his name, and his presence is tangible in the paintings and photographs that hang throughout the house. His "hereafter" is truly perpetuated in the invaluable artistic legacy that records Harry Lieberman's remarkable passage through this world.

68. *Whosoever Reports a Thing*, c.1974, acrylic on canvas, 24″ x 30″. (Museum of American Folk Art; Gift of a Friend of the Museum) If you tell a thing that helps another person, you bring honor to yourself. I use the story of Purim to show this. Ahasuerus, the king of Persia, made Esther his queen. He didn't know she was Jewish. Her uncle, Mordecai, overheard a plan to kill the king and told Esther. The king was saved, and Mordecai's good deed was written in the royal book. Haman, the top minister, got furious when Mordecai wouldn't bow to him like to a god. He made a plan where Mordecai should be hanged and the Jews destroyed. Mordecai asked Esther, being she was queen, that she should use her influence to put a stop to this. Esther invited Haman and the king to a banquet. When the king read in the royal book that Mordecai had saved his life, he asked Haman, "How do you reward a faithful person?" Haman, supposing it meant him, said, "Crown him and honor him in a parade." The king made him do this for Mordecai (fig. 69). Then Esther told about Haman's terrible intentions, and Haman was hanged. ☆ The Pirkei Avot 6:6 says: "Lo, thou hast learnst that he that tells a thing in the name of him that said it brings deliverance unto the world, for it is written. And Esther told the king thereof in Mordecai's name (Megilat Esther 2:22)." The recitation of the Book of Esther has become the occasion for revelry and celebration, and the events of the story have inspired visual depictions for centuries. Favorite scenes are Haman leading Mordecai, resplendent on a white steed, and portraits of Esther and Ahasuerus seated on thrones. In the nineteenth century, perforated-paper images embroidered with wool threads became popular handicrafts and presented the story in a linear, narrative manner in vertical rows. Lieberman has painted this critical scene in the Purim story in fiery colors of gold and orange. Esther has appeared before the king without permission. The weapons around the chamber indicate the king's right to put her to death for her impudence, but he grants the audience and Esther is allowed to speak. Through her bravery, the lives of the Jews are redeemed and the wicked Haman is hanged.

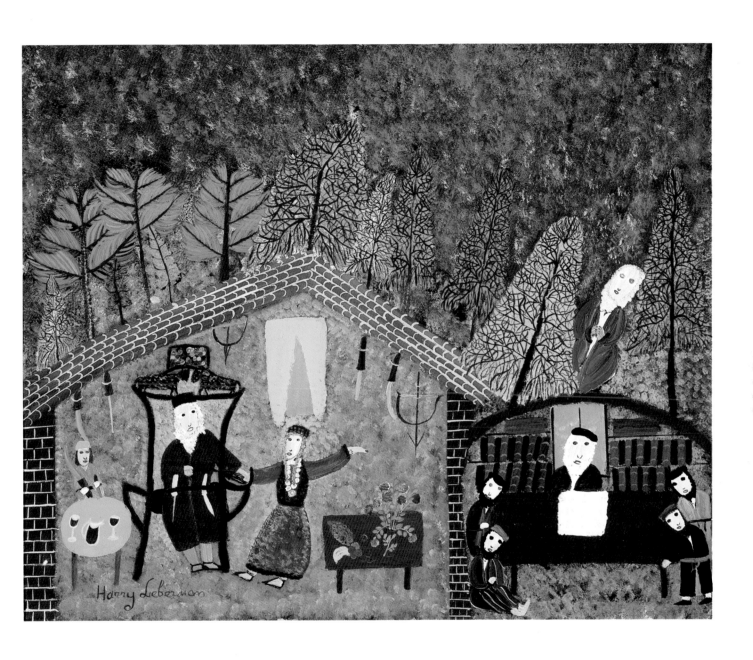

69. *Mordecai and Haman*, c.1968, acrylic on canvas, 24″ x 30″. (Private collection) Mordecai and some of his friends were discussing Torah in the town when they saw Haman approaching. Mordecai told his friends to flee, for he knew that Haman was an enemy of the Jews and that Haman wanted to kill him. But his friends said, "No, we will stay here with you and see what happens." And as it happened, Haman had just come from the king, who had learned that Mordecai had saved his life. The king therefore ordered Haman to honor Mordecai—to put him on a horse that the king had ridden and to dress him in the king's robes with the king's crown upon his head; then to lead him through the city crying, "This shall be done to the man whom the king delights to honor." And so Haman had to honor Mordecai in this way even though he hated him. Now it had just passed the time when the first omer of wheat was delivered as sacrifice and Mordecai remarked on this to his friends. Haman overheard him and said, "Your omer of wheat counted more than my ten talents of gold," for he had offered the king the talents of gold for permission to kill all the Jews and was instead forced to honor Mordecai. "Hate leads to madness. Hitler's hatred and murder of the Jews ended in his dying a madman—so did Haman allow his hatred of all the Jews to drive him to madness and destruction." ☆ According to some authorities, the text of the Book of Esther originated as a letter to the Jews of the Persian provinces, telling them to initiate the celebration of Purim after the historical events had taken place. The story was told as a recitation of fact. Any pejorative reflections on the king are confined to the oral traditions and midrashim surrounding the Book of Esther. This is the only Jewish text that omits the name of God. Some commentators feel that this was so that if the book was copied by the Persians, the names of their own deities could not be substituted.[64] Although Lieberman's explanation says that Mordecai was discussing Torah with his friends, midrashic interpretation claims he was in the study hall with his pupils, speaking of the omer sacrifice offered on Passover. Indeed, Lieberman's depiction appears to be of children and not contemporaries of Mordecai. The field of grain lies behind the study house and Haman is shown leading a small white horse to Mordecai. Queen Esther and her maidens sit in a royal chamber fasting for the successful outcome of her petition to the king. Images of this scene usually show Mordecai already mounted on the white steed, but Lieberman has chosen the psychological moment just before this takes place.

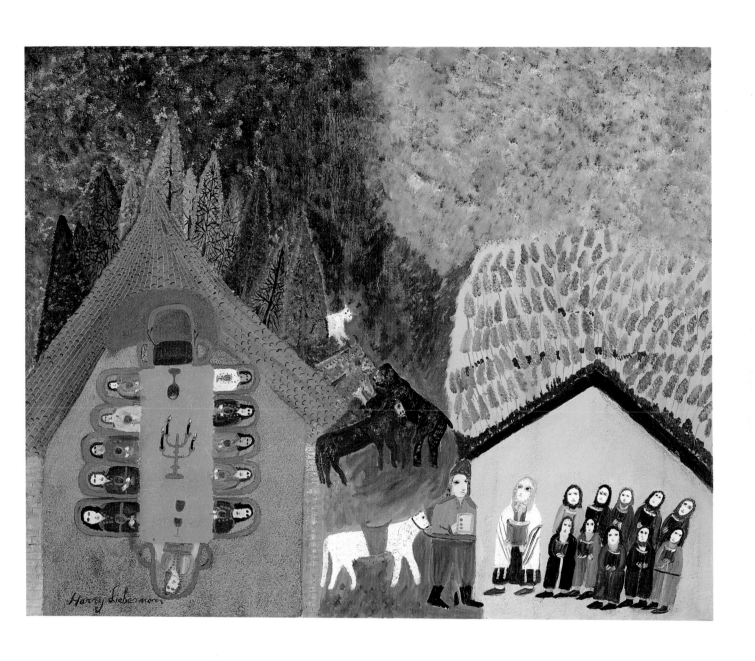

70. Untitled (The Story of Jonah), c.1980, acrylic on canvas, 30″ x 40″. (Private collection) Although this painting bears no title, it is apparently a rendition of the story of the prophet Jonah, which is read in its entirety on Yom Kippur. The story of Jonah differs from those of the other prophets because it contains no actual prophecy. Jonah, believing his message of doom will result only in his own rejection by the people of Ninevah, attempts to flee his mission by taking to the sea. The seventy nations of the world are all represented on the ship (Lieberman has painted exactly seventy persons on board). Jonah's illicit presence causes God to stir up a mighty storm, and the nations of the world call upon their gods to save them, but with no effect. They then cast lots to decide who to blame for the storm. When they discover Jonah sleeping through the storm, they recognize him as the culprit, and he volunteers to be thrown overboard to appease the wrath of God. A huge fish swallows Jonah and from the belly of the fish he offers up a prayer to God. A midrashic interpretation says that the fish's two eyes were windows that permitted Jonah to see the wonders of the subterranean world, and a luminous pearl inside the fish lit the prophet's way. God responds to Jonah's prayer and the fish vomits him onto shore. God asks Jonah a second time to visit Ninevah and prophesy to its inhabitants, and this time Jonah complies. The people of Ninevah believe Jonah's words and turn from their sinful ways, causing God to revoke his threatened punishment. Jonah complains that this was just as he had feared and the very reason he had tried to flee. He left the city and settled nearby to watch what events might transpire. To teach Jonah a lesson, God provided a shady tree which grew overnight and pleased Jonah because of the comfort it provided. God then caused the tree to wither, so that when the sun rose, the heat beat down upon Jonah. When Jonah prayed for death as a result, God chastised him for caring more about the life of the tree than he had about the lives of thousands of Ninevites. The boat seems to carry the action of the story forward; at its stern is the fish about to swallow Jonah, at its bow the fish has spewed Jonah onto dry land. Jonah stands under a divided tree. It is green and leafy on the left and dry and dead on the right. The fierce sun overhead sprays burning sparks onto Jonah while to the West stands the redeemed city of Ninevah.

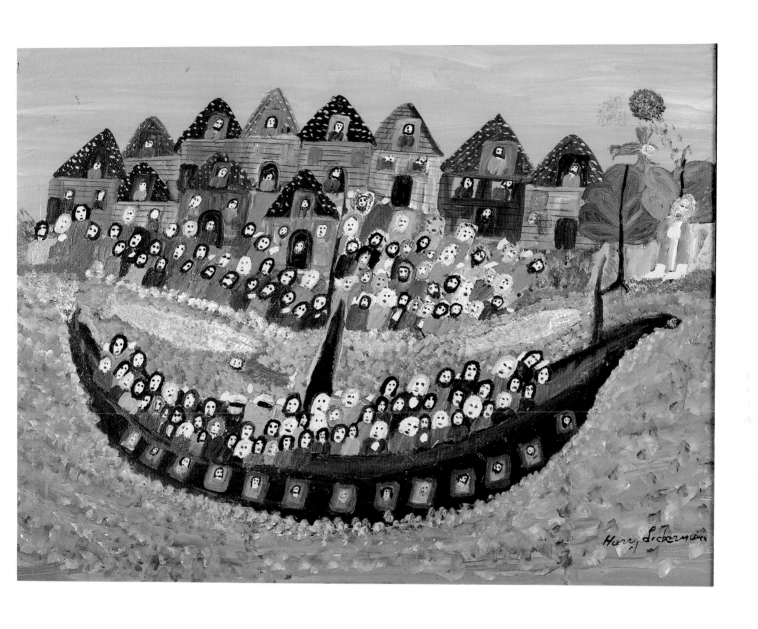

71. *One God*, c.1971, acrylic on canvas, 24″ x 20″. (Private collection) Long ago, before Abraham, the people of the world were polytheistic. They believed that there was a god for every natural phenomenon and gods for every family. Abraham was the first man to believe in one all-powerful God. The commentators tell the story this way: In the province of Khan, there was a city called Oer. The king of the province, named Nimrot, had been told by a prophet that a son of Terach, who lived in Oer, would originate a monotheistic religion. The son, of course, was Abraham. Nimrot was afraid of this change and offered Terach gold and jewels for the life of his son. Terach answered that like the horse who had been offered all the oats in the world if he would allow his head to be chopped off, that without his head, he would have no need for oats. So, said Terach, without his son, there would not be no use for riches. Since he knew that Nimrot would not be so easily satisfied, Terach hid Abraham in a cave till he was an adult and would be safe. When Abraham grew up, and emerged from the cave, it was day, and he saw the sun and he said, "That must be God, since it is so bright." But when the sun went down he decided that it couldn't be God since God was permanent. He thought the same thing about the moon and the stars, and when he saw that none of these was permanent, he concluded that there must be one God who is supreme over all things. ☆ Abraham's conclusion about the nature of God was reached through logical deduction and underlies the rational nature of Judaism. In the painting Abraham stands in a veritable Garden of Eden with trees and flowers and two companions. The painting is divided by a diagonal slash that creates an aura suggestive of the legends that have grown around the figure of Abraham. These legends indicate a birth foretold by cosmological signs. The moon sets on one side of this division, the sun on the other and the lower half is speckled with stars. Abraham, shown as an elderly man (a sign of wisdom), stands beneath the forces of nature with a banner held high that bears a single word—"ECHAD" (ONE). Nimrot's desire for Abraham to be sacrificed seems to presage the story of the Akedah. But whereas the Akedah was a test of faith and warranted compliance, Nimrot's request was founded on superstitious fear and was thus rejected.

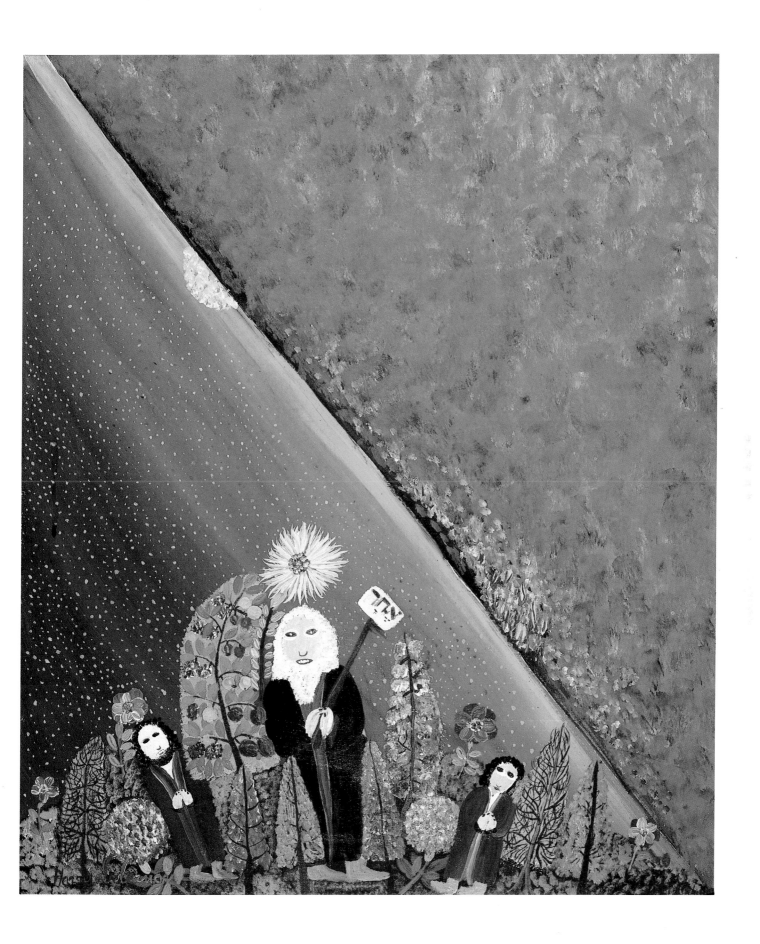

101

72. *The Covenant*, 1963, oil on canvas, 30″ x 40″. (Courtesy the Morris Gallery, New York)

8 And he said: Oh, Lord God, whereby shall I know that I shall inherit it?

9 And he said unto him, "Take ye a heifer of three years old and a she-goat of three years old and a ram of three years old and a turtle dove and a young pigeon."

10 And he took unto him all these and divided them in the midst and he laid each piece one opposite the other; but the birds he did not divide.

11 And the birds of prey came down upon the carcasses but Abraham drove them away.

12 And when the sun was going down a deep sleep fell upon Abraham and lo a horror, dark and great, fell upon him. (Genesis 15: 8–12)

6 And Abraham took the wood for the burnt offering and laid it upon Isaac his son and he took in his hand the fire and the knife and they went both of them together.

7 And Isaac spoke unto Abraham, his father, and said, "My father," and he said, "Here am I, my son," and he said, "Behold, here is the fire and the wood, but where is the lamb for the burnt offering?"

8 And Abraham said, "God will provide himself the lamb for the burnt offering, my son. So they went both of them together.

9 And they came to the place which God had told him of and Abraham built there an altar and laid the wood in order and bound Isaac his son and laid him on the altar above the wood.

10 And Abraham stretched forth his hand and took the knife to slay his son.

11 The angel of the Lord called to him out of heaven and said, "Abraham, Abraham," and he said, "Here am I."

12 And he said "lay not thy hand upon the lad, neither do thou the least unto him for now I know that thou fearest God seeing that thou has not withheld thy son, thy only one, from me." (Genesis 22: 6–12)

☆ When God told Abraham that his own child would inherit his land, Abraham wanted proof. Assurance was granted in the form of a covenant made between God and Abraham. God later demanded his own proof of Abraham's faith in the events of the Akedah. God told Abraham to prepare for their pact by "dividing" the bodies of the sacrificial animals. This signified the two parties making the covenant; as the two halves of the bodies formed one whole, so did the two parties come together in the covenant to form one. The flaming arc represents the "smoking furnace and a flaming torch passed between the halves of the animals" (Gen.15:17). On the bottom, Abraham leaves with Isaac and his manservants for the Temple Mount where he has been instructed to sacrifice his son. The Akedah is shown on the upper left portion. This painting is composed of triangular configurations that are echoed in the conical trees and Abraham's tent. The trees diminish in size as they line the roads that all lead to a distant point in the center of the painting. The paths of Abraham's life also led to a single divine point, the monotheism that is the basis of Judaism.

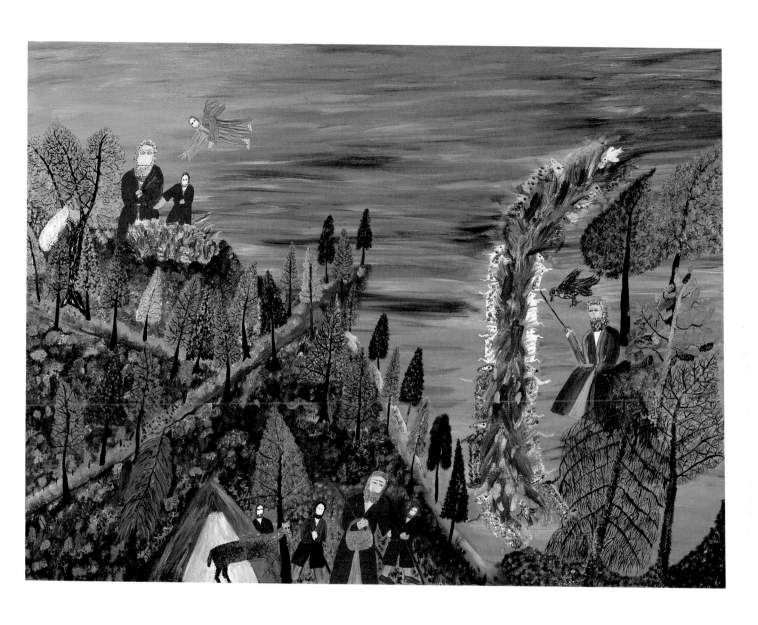

73. *The Sacrifice of Isaac II*, 1982, acrylic on canvas paper, 20″ x 16″. (Private collection) When Abraham brought Isaac up to the altar and was about to sacrifice him the angel came to him and said, "God wants no more human sacrifice. Bring a sheep instead as a sacrifice." This change signaled the end of the cult of Molekh that advocated the sacrifice of the eldest child to God. Abraham's manager and manservant Eliezer and Ishmael, the son of Abraham by Hager, wait on the side. ☆ The story of the "Akedah" or "Binding of Isaac," has been called the "cornerstone of rabbinic theology." Midrashic interpretation endows each element of the story with cosmic significance, going back to the creation of the universe (fig. 44). The Akedah is one of the earliest images in Jewish art and is usually shown as symbolic representations of individual elements or as depictions of the three main components of the story. Lieberman shows the three episodes in a triangular composition with the Akedah forming the pinnacle of the triangle. The ram is placed just below, its horns caught in a bush. The base of the triangle is formed by the two servants and the donkey, on the left, and the conclusion of the story, on the right. Paramount is the figure of Abraham, his arm raised to strike his son. At the same time, his finger points to the "makom" or place, where the Shekinah first made itself known, according to legend. Abraham and Isaac leave the site carrying the shofar made from the ram's horn, which will one day be blown to announce that the Messiah has come. The angel of God watches from above and witnesses Abraham's willingness to sacrifice his only son and Isaac's compliance before saying, "Abraham, Abraham! Do not lay your hand upon the lad, nor do him any harm." (Gen.:22:11-12) At this moment, Abraham sees the ram which is sacrificed in Isaac's stead. Lieberman shows this event as the end of the era of sacrifice—Molekh— that was a ritual related to idolatrous practices. This is one of Lieberman's later painting, executed when he was in his one hundred-and-second year. The deterioration of fine detail is evident in the crudely delineated tree branches and schematic figures. But the luminous surface of the painting and use of color reflect the undiminished strength of Lieberman's compositional and narrative abilities.

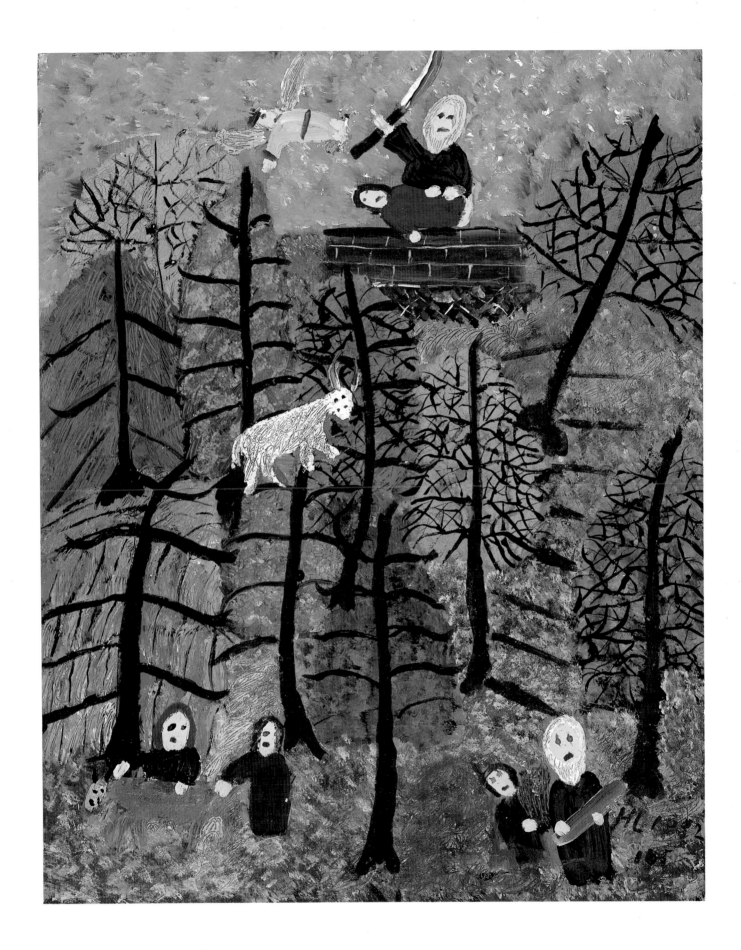

74. *Where Is Mercy,* 1972, acrylic on canvas, 30″ x 40″. (Collection of Lanford Wilson) The Holy One, blessed be He, said to the ministering angels, "Let us go and see what the enemies have done to my house"…The Holy One, blessed be He, wept and said, "Alas! My house! Oh, my children, where are you? My priests, where are you? My dear ones, where are you?"…The Holy One, blessed be He, said to Jeremiah. "Go and call Abraham, Isaac, and Jacob,…from their graves"…He called and wept until he reached the patriarchs. Said Rabbi Samuel, son of Nahman, "When the Temple was destroyed, Abraham came before the Holy One, blessed be He, weeping and plucking the hairs of his beard and head, tearing his clothes, piling ashes on his head, after he had walked through the Temple, crying, "Why am I different from all other nations that I have been exposed to such shame?…Why have I exiled my children, sold them to foreign nations, and inflicted death upon them?"

Said Abraham to the Holy One, blessed be He, "Master of the Universe, when I was a hundred years old, you gave me a son. When he reached maturity and the age of thirty-seven, you told me to offer him up as a burnt offering. I pretended cruelty and mercilessness—with my own hands I bound him…Will you not be cognizant of this and show mercy to my children?"

Said Isaac, "Master of the Universe, when my father said, 'God will see to the sheep for His burnt offering, my son,' I did not hesitate but willingly allowed myself to be bound, exposing myself to the knife. Will you not be cognizant of this?"

Immediately, Moses and Jeremiah went ahead until they reached the rivers of Babylon. As soon as Moses appeared, people said one to another, "The son of Abraham has come from his grave to redeem us from our enemies." A heavenly voice called out, "It has been decreed already." Whereupon Moses said, "My children, it is impossible to do so now."

When Moses came to the patriarchs, they asked him, "What have the enemies done to our children?" Replied Moses, "Some were killed. Some had their hands tied behind them, some were bound in iron chains, some were stripped naked, and the rest died on the way." He continued, "I wrote in your Torah, 'Do not slaughter an ox or a sheep together with their young in the same day.' Now mothers and their children have been killed and you are silent?" At that moment, Rachel appeared and said, "Master of the Universe, you are well aware that your servant Jacob…worked for my father for my sake for seven years…and when the time for our marriage arrived, my father decided to substitute my sister for me…In order not to embarrass her, I helped her to pretend that she was Rachel. I was not jealous of her and did not cause her shame. O, Living King, if I, a poor mortal, showed mercy even in my deep suffering, why do you favor the pagans, allowing them to exile and murder my children at will?" ☆ This text comes from the *Eikhah Rabbah,* the midrash on the Book of Lamentations. The ghost-like spirits of the patriarchs loom in the background, unable to prevent the Jews from being killed or bound in iron chains and exiled from their homes. When questioned about the meaning of this painting, Lieberman replied, "Where was the mercy of the six million?" referring to the Jewish lives lost in the Holocaust.

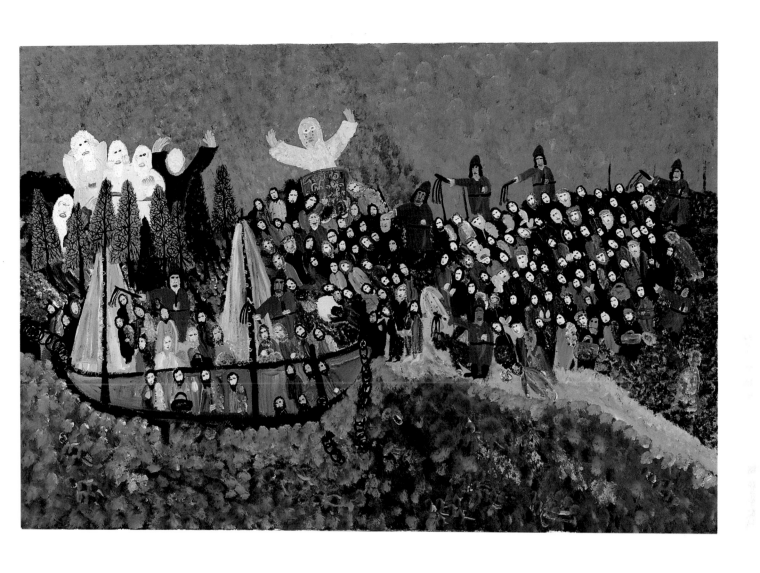

75. *The Blessing and the Curse*, c.1970, acrylic on canvas, 40″ x 30″. (Collection of Helen Popkin in memory of Rose Blake) Moses commanded to the elders of Israel, when they crossed the Jordan, that they should put up twelve stones on Mount Ebal and write the laws on them so everybody could read. Then Simeon, Levi, Issacher, Judah, Joseph, and Benjamin should stay on Mount Gerizim to bless the people who worshipped and acted according to the laws. Reuben, Gad, Asher, Zebulon, Dan, and Naphtali should stay on Mount Ebal to curse those who worshipped idols and sinned against the laws. I think the symbol is, you get from heaven the privilege to understand what is right and what is wrong. You do good, you will be blessed. You do wrong, you really are cursing yourself. The religious person believes no wrong comes from up there because all is heavenly in Paradise. Any suffering that happens down here is your fault and your punishment is down here. ☆ Lieberman places the two groups described in Deuteronomy 27:1-13 on each side of the canvas. Reuben, Gad, Asher, Zebulon, Dan, and Naphtali stand behind the twelve stones on Mount Ebal for the curse. The twelve stones are placed on the mountain both as a consolation for the tribes associated with the mountain and as a reminder to follow the laws of the Torah or suffer the curse. The twelve stones are to be plastered with lime. Lieberman has cut twelve pieces of paper printed with Hebrew type and pasted them on the canvas. Each paper "stone" is heavily outlined with white acrylic to resemble lime plaster. Simeon, Levi, Judah, Issacher, Joseph, and Benjamin stand on Mount Gerizim to receive the blessing. Below, the members of the twelve tribes rejoice as they get ready to cross the Jordan. Three figures in the front are blowing shofars, or ram's horns, while the musicians on the far left resemble the itinerant Jewish klezmer bands of Eastern Europe.

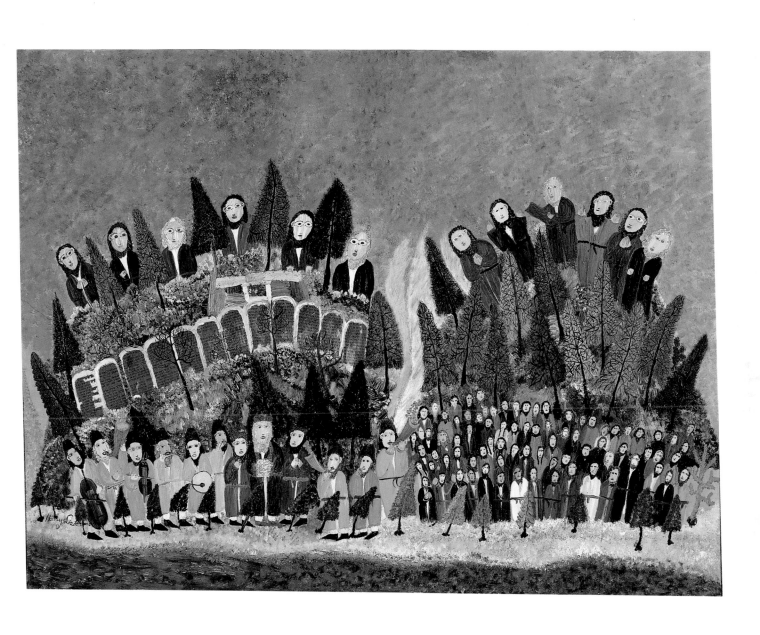

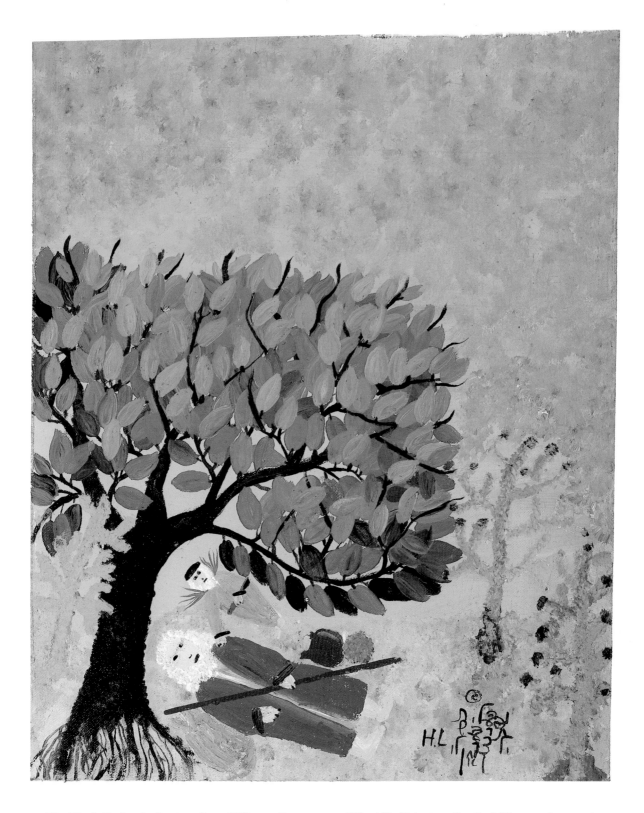

76. *Elijah Under the Juniper Tree*, 1976, acrylic on paper, 20″ x 16″. (Private collection) The angel comes to Elijah with bread and water in his forty days journey while Elijah lies asleep under the juniper tree. ☆ The prophet Elijah lies under the juniper tree surrounded by desert, sand, and cacti. The horizontal elements of the leafage, the sleeping figure, and the sand are relieved by the verticality of the cacti and the tree trunk. The composition is settled near the lower half of the paper, with a large expanse of blue sky suggesting the heat of the desert and the flat landscape. But the overwhelming sense of blue also suggests the canopy of God's protection over Elijah, the one prophet who remained faithful to the ways of God. Kabbalists saw in this story a "…mystical experience of spiritual awakening through which something novel is revealed."[57] Elijah became a central figure to Hasidism because of this spiritual awakening that paralleled the movement's self-perception.

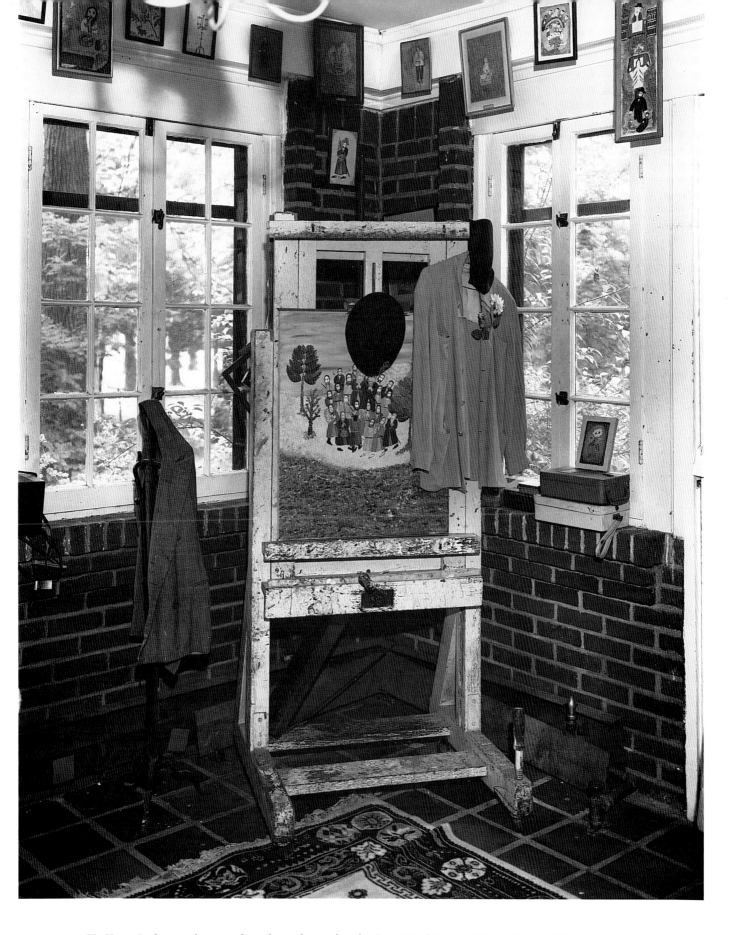

77. Harry Lieberman's original easel was donated to the Great Neck Senior Citizen Center. This second easel still stands in the sunroom in Lieberman's Great Neck home. His smock, his beret, and one of his canvases hang on the easel, a testimony to the many hours Lieberman spent painting in this room.

GLOSSARY

aggadah—commentaries, parables, history, legends, and other non-legal writings found in the Talmud and the Midrash.

Akedah—the Binding of Isaac related in Genesis 22:1-19.

Baal Shem Tov—literally "Master of the Good Name," the title by which the founder of Hasidism, Israel ben Eliezer (1698–1760), became commonly known.

bimah—the raised platform, usually situated at the front or center of the synagogue, from which the Torah is read.

cantor—a singer of liturgical music appointed to lead the synagogue prayer service.

cheder—elementary school for Jewish study.

chupa—canopy beneath which the marriage ceremony is conducted.

Crown of Torah—a recurring motif in Jewish art, one of the four crowns mentioned in the Pirkei Avot 4:17.

devekkut—a biblical term that means close attachment to God. In the Middle Ages, the term assumed mystical significance, coming to mean a concentration on prayer, wording, and mysticism leading to a direct communion with God and possession by the holy spirit—Ruach ha-Kodesh.

diaspora—the dispersion and exile of the Jewish people from the Land of Israel after the destruction of the Second Temple in 70 CE.

etrog—a citrus fruit resembling a lemon that is one of the four species of plants used during the Sukkot liturgy.

Gemara—the rabbinical discussions of the Mishnah compiled during the two centuries following the codification of the Oral Law and the three centuries in Babylonia.

halakhah—the legal and binding aspects of Jewish religious obligations as described in the Torah, the Talmud, and rabbinic texts.

Hallel—hymns of thanksgiving and praise to God derived from the Book of Psalms and recited as part of the liturgy during festive holidays.

Hasidism—a revivalist Jewish movement that was founded in Poland in the eighteenth century by Israel ben Eliezer and spread throughout Eastern Europe. Hasidism emphasized a joyous affirmation of life through pious acts and prayer and the potential to achieve a direct communication with the Godhead through such piety and fervency of prayer.

Haskalah—the movement of Jewish secular enlightenment that began in Europe in the late-eighteenth century.

Kabbalah—the major system of Jewish mystical and esoteric thought that developed at the end of the twelfth century.

Korach—the leader of the rebellion against Moses related in Numbers 16:1.

landsman—a fellow countryman.

Litvak—a Lithuanian Jew.

lulav—three of the four species that must be present during the liturgy of the Sukkot holiday. It is composed of one branch each of myrtle, palm, and willow, and is used with the etrog during the religious service.

maskilim—adherents of Haskalah.

menorah—the seven-branched candelabrum originally used in the biblical sanctuary and Jerusalem Temple; also an eight-branched candelabrum used during the holiday of Hanukkah.

mezuzah—a scroll of parchment inscribed with specific biblical passages (Deut. 6:4-9, 11:13-21) that is attached to the doorpost of a Jewish home, usually in a protective cover.

Midrash—the term is applied both to the rabbinic commentaries on the Bible that clarify legal issues or teach lessons through story, parable, legends, and

other literary devices, and to the body of literature thus generated.

Mishnah—the codification of the Oral Laws, the Jewish legal traditions, compiled and edited by Judah ha-Nasi, or Patriarch, around the beginning of the third century CE.

mitnagdim—the traditional opponents in Eastern Europe of the Hasidic movement.

mizrah—a decorative wallhanging placed on the eastern wall of Jewish homes or communal centers to indicate the proper direction of prayer East toward Jerusalem.

omer—a measure of a sheaf of new barley offered in the Temple on the second day of Passover, the sixteenth of the Hebrew month of Nisan. Also, the name of the period between the holidays of Passover and Shavuot.

peyes—the uncut sidelocks worn by Hasidic men.

pinkas—a book of minutes or records of a society in a Jewish community.

Pirkei Avot—the ninth tractate of the Order Nezikin in the Mishnah; a collection of rabbinic sayings that emphasize ethics, Torah study, and religious observance in Jewish life.

Purim—the festival celebrated on the fourteenth of the Hebrew month of Adar that commemorates the escape of Persian Jewry from destruction by Haman, chief minister of King Ahasuerus.

sefirot—Kabbalistic term for the ten emanations from and contained within the Godhead. Each is named and identified with an attribute of the Divine Presence.

Shabbat (also **Shabbos**)—the Sabbath, the day of rest that commemorates the seventh day of the act of Creation, the covenant between God and the people of Israel, and the exodus from Egypt. Work is prohibited on this day and behavior is strictly prescribed.

Shekinah—the Divine Presence; sometimes identified with the female aspect of God.

shiviti—a devotional plaque found in a synagogue and bearing the verse "shiviti Adonai le-negdi" ("I am ever mindful of the Lord's presence"—Psalm 16:8).

shofar—a ram's horn that is blown during the Rosh Hashanah and Yom Kippur service as a call to repentance.

shohet—ritual slaughterer; butcher.

shtetl—East European Jewish village.

shtibl—Hasidic prayer and study house.

shtiblekh—plural form of **shtibl**.

shul—traditional synagogue.

Simhat Torah—the one-day celebration at the end of Sukkot that marks the completion of the year-long reading of the Torah scroll and the commencement of the next reading cycle.

shtreimel—a fur-brimmed hat worn by Hasidic men. It is made of thirteen sable tails and is interpreted as symbolizing the thirteen qualities of Divine mercy.

Sukkot—the Feast of Tabernacles that originally had agricultural significance and begins four days after Yom Kippur.

tallit—a prayer shawl.

Talmud—the compilation of seven centuries of Jewish law and lore from c.200BCE–c.500CE in Israel and Babylonia. It includes the Mishnah and the Gemara. The two versions are the Jerusalem Talmud and the Babylonian Talmud.

Torah—parchment scroll inscribed with the first five books of the Hebrew Bible.

Torat Moshe—the Five Books of Moses, the Torah.

tzimtzum—theory of contraction and emanation developed by the mystic Isaac Luria (1534–1572) to explain the Creation.

tzitzes—a four-cornered fringed undergarment worn by observant Jewish males. It is traditionally made of wool or linen and must include a blue thread on each corner.

yahrzeit—anniversary of a death observed by close relatives.

yarmulke—a skullcap, the traditional headcovering worn by Jewish males.

yeshiva—school of advanced rabbinic study.

yizker-bukh—memorial book compiled by Jewish survivors of World War II to commemorate the destroyed Jewish villages and towns of Eastern Europe.

Yom Kippur—Day of Atonement, which is marked by fasting and prayer and falls on the tenth day of the Hebrew month of Tishri.

NOTES

1. Elizabeth Warren, Jean Lipman, Dr. Robert Bishop, Sharon Eisenstat, *Five Star Folk Art: One Hundred American Masterpieces* (New York: Harry N. Abrams, Inc., 1990).

2. Susan Larsen-Martin and Lauri Robert Martin, *Pioneers in Paradise: Folk and Outsider Artists of the West Coast* (Long Beach, California: Long Beach Museum of Art and Department of Parks and Recreation, 1984).

3. Peggy Mann, "Age: 101—Motto: "Go Do!," *Reader's Digest* (August 1978).

4. Robert McG. Thomas, Jr., "100 Years of Living, 20 Years of Painting," *The New York Times*, March 13, 1977.

5. Gerard C. Wertkin and Norman L. Kleeblatt, *The Jewish Heritage in American Folk Art*, The Jewish Museum, New York, and the Museum of American Folk Art, New York (New York: Universe Books, 1984), p. 14.

6. Avram Kampf, "In Quest of the Jewish Style in the Era of the Russian Revolution," *Journal of Jewish Art*, 5 (1978), p. 48.

7. Ibid., p. 49.

8. Ibid., p. 50.

9. Barbara Kirshenblatt-Gimblet, "Objects of Memory: Material Culture as Life Review," *Folk Groups and Folklore Genres A Reader*, Elliott Oring, ed. (Logan, Utah: Utah State University Press, 1989), p. 332.

10. Ibid., p. 331.

11. Eugene Ionesco as quoted in Kirshenblatt-Gimblett, op. cit., p. 331.

12. I am indebted to Rabbi Haskell Bernat for providing the source of this text.

13. Rev. Dr. A. Cohen, revised and expanded by Rabbi A. J. Rosenberg, *The Five Megilloth* (London and New York: The Soncino Press, 1984), p. 19.

14. Arthur J. Magida, "The Last Portrait," *The New York Times*, June 24, 1983.

15. Ronald Sanders, *Shores of Refuge A Hundred Years of Jewish Emigration* (New York: Schocken Books, Inc., 1988), p. xi.

16. Ibid., p. 36.

17. Ibid., p. 36.

18. For example, many immigrants from Bialystok moved to the Lower East Side of New York City. Today, their presence is still felt in the street name, Bialystoker Place, their shul, the Bialystoker synagogue, and the bakery a few blocks away that still makes fresh "bialies," a doughnut-shaped bread from Bialystok. See also: Jack Kugelmass and Jeffrey Schandler, "Going Home: How American Jews Invent the Old World," (New York : YIVO Institute for Jewish Research, 1989), p. 8.

19. Sanders, op. cit., pp. 165–166.

20. David Shtokfish, ed., *Gniewoszów Memorial Book* (Tel Aviv, Israel; Association of Gniewoszów in Israel and the Diaspora, 1971), pp. 3–5.

21. Roman Mogilanski, comp. and ed., *The Ghetto Anthology*, rev. by Benjamin Grey (American Congress of Jews from Poland and Survivors of Concentration Camps, Inc., 1985), p. 124.

22. J. Kugelmass and Schandler, op. cit., p. 18.

23. Jack Kugelmass and Jonathan Boyarin, *From a Ruined Garden* (New York: Schocken Books, Inc., 1983), p. 2.

24. Harry M. Rabinowicz, *Hasidism the Movement and Its Masters* (Northvale, New Jersey, and London: Jason Aronson, Inc., 1988), p. 27.

25. The candelabra representing the light of the Great Temple follows the form dictated in Exodus 25:31–40. Its base, stem, and decorated cups, spheres, and flowers must be hammered of a single piece of gold. The flower-like components are often depicted as a series of beads or knobs along the silhouette of the menorah.

26. Conversation with Erica Popkin, 1989. His last place of residence in Poland, according to the passenger lists of 1906, was the nearby town of Romosc.

27. Although the identity of Mr. Kormann or Konmann has not yet been determined, his name is very similar to the name of Lieberman's future father-in-law.

28. Harry Lieberman, taped conversation, 1979.

29. Hannah Grad Goodman, "Brushing Up on the Talmud Harry Lieberman at 106," *Hadassah Magazine*, 1982, p. 19.

30. Peggy Mann, "A Portrait of the Artist at 103," *USAir Magazine*, Vol. I, Number 3 (November 1979), p. 76.

31. Sanders, op, cit., p. 381.

32. Ibid., p. 386.

33. Rabbi Marc Liebhaber, "From Friday to Friday, When Life Is a Message A Tribute to Uncle at 106," *American Jewish World*, November 19, 1982, p. 3. Rabbi Liebhaber refers to his uncle as Hertzke Aaron, which means Hertzke, son of Aaron.

34. Hannah Grad Goodman, op. cit., p. 19.

35. Harry Lieberman, recorded conversation, 1979.

36. Ibid.

37. Peggy Mann, op. cit., p. 74.

38. Ibid., p. 74.

39. Julia Weissman, "The Testament of Harry Lieberman" (unpublished manuscript, no date), p. 3.

40. Will Kramer, "The Second Life of Harry Lieberman," *The Jewish Chronicle*, June 8, 1979.

41. Celia Hubbard, "The Visual Arts," *The Living Light A Christian Education Review*, Vol. 5, Number 1 (Spring 1968), pp. 100–105.

42. Harry M. Rabinowicz, op. cit., p. xi.

43. Ibid., p. xi.

44. Ibid., pp. 14, 18.

45. Louis I. Newman, *Hasidic Anthology* (New York: Schocken Books, Inc., 1963), p. 44.

46. Ibid., p. 38.

47. Exhibition notes, Hebrew Union College Skirball Museum of Art, Los Angeles, California, 1981.

48. Elie Wiesel, *Souls on Fire* (New York, Random House, 1972), p. 16.

49. Raphael Patai, *On Jewish Folklore* (Detroit, Michigan: Wayne State University Press, 1983), p. 86.

50. Ibid., p. 88.

51. Wertkin and Kleeblatt, op. cit., p. 24.

52. Gabrielle Sed-Rajna, *The Hebrew Bible in Medieval Illuminated Manuscript* (New York: Rizzoli International Publications, 1987), p. 7.

53. Wertkin and Kleeblatt, op cit., p. 26.

54. Babylonian Talmud, Berakhot p. 59b, Soncino translation, as quoted in "The Beit Alpha Mosaic Toward an Interpretation," John Wilkinson, *Journal of Jewish Art*, 5 (1978), p. 21.

55. "The Testament of Harry Lieberman," as transcribed by Julia Weissman, p. 2.

56. Irving Howe and Eliezer Greenberg, eds., *A Treasury of Yiddish Stories* (New York: Schocken Books, Inc., 1973), p. 620.

57. Gershom Scholem, *Kabbalah* (New York: Dorset Press, 1974), p. 43.

58. Ibid., p. 2.

59. Laura Lipsett, "Meet Harry Lieberman—Artist Extraordinaire," *North Shore*, Vol. 5, Number 3 (April–May 1980), p. 16.

60. Harry Lieberman, testimony before the House Select Committee on Aging, November 14, 1979, transcribed by Julia Weissman.

61. Marjorie Hunt, Mary Hufford, Steven Zeitlen, *The Grand Generation: Memory, Mastery, Legacy* (Washington, D.C.: Smithsonian Institution Traveling Exhibition Service and Office of Folklife Programs; Seattle, Washington, and London: University of Washington Press, 1987), p. 56.

62. Raphael Patai, op. cit., p. 35.

63. Hannah Grad Goodman, op. cit., p. 24.

64. Rev. Dr. A. Cohen, op. cit., p. 121.